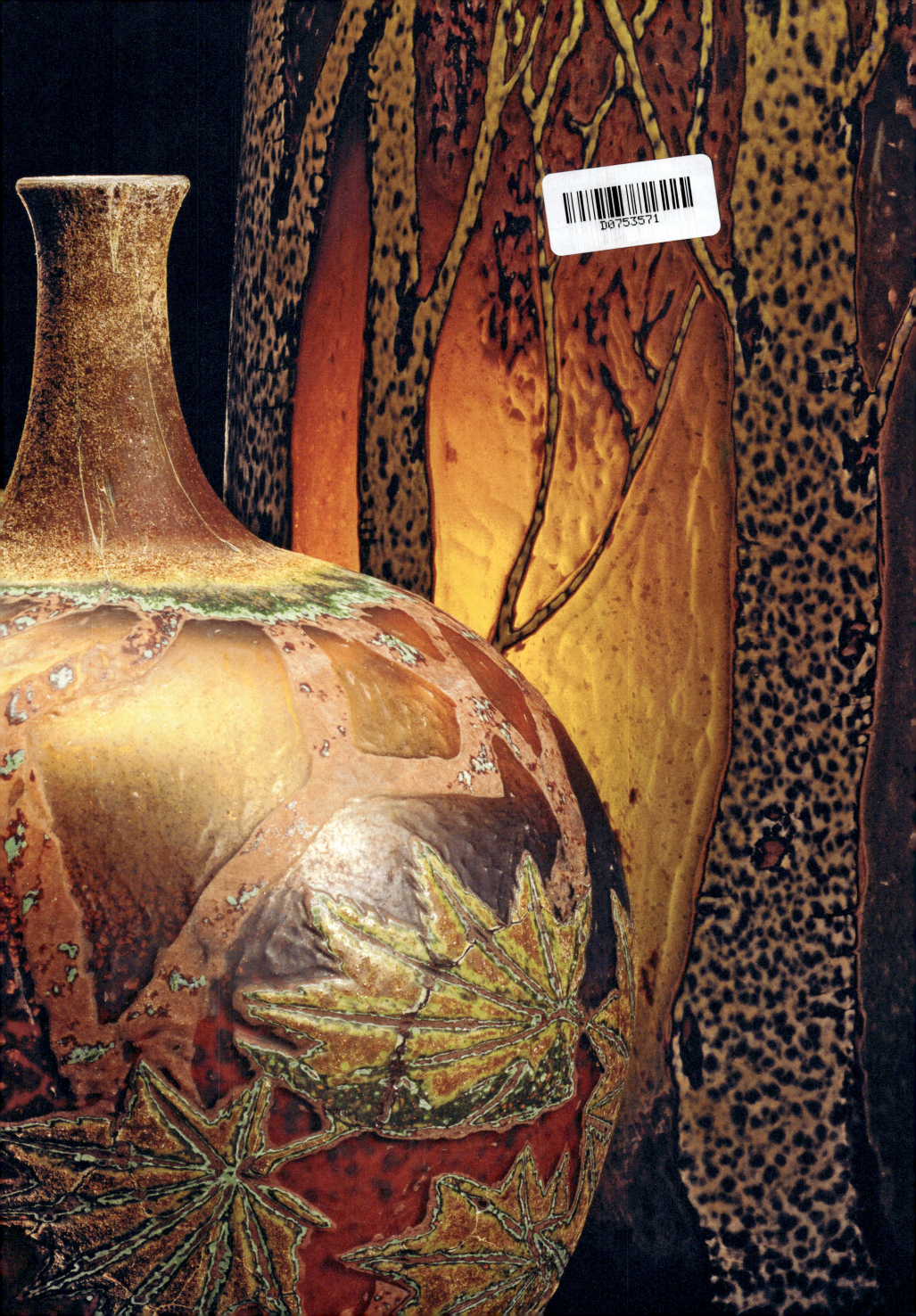

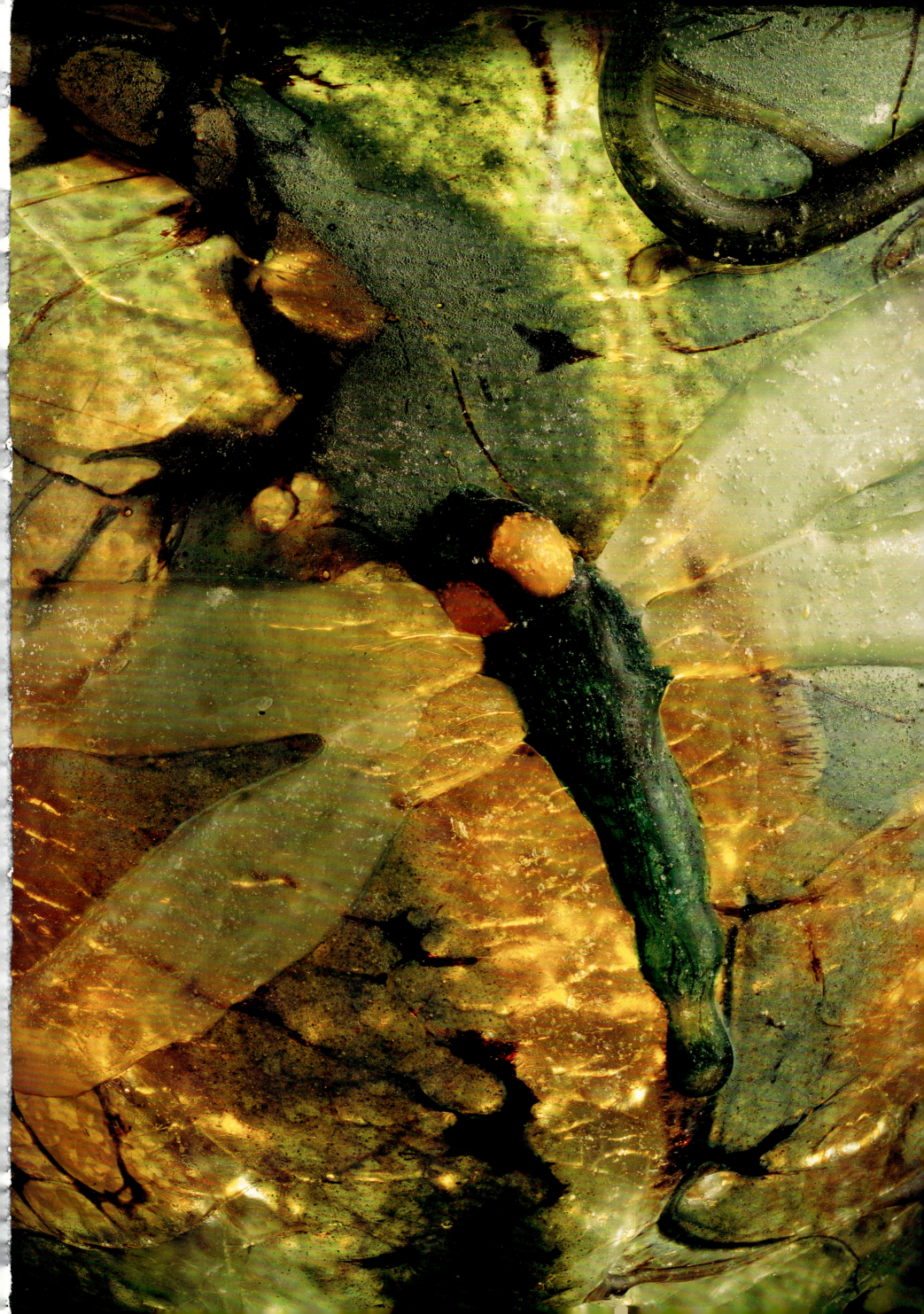

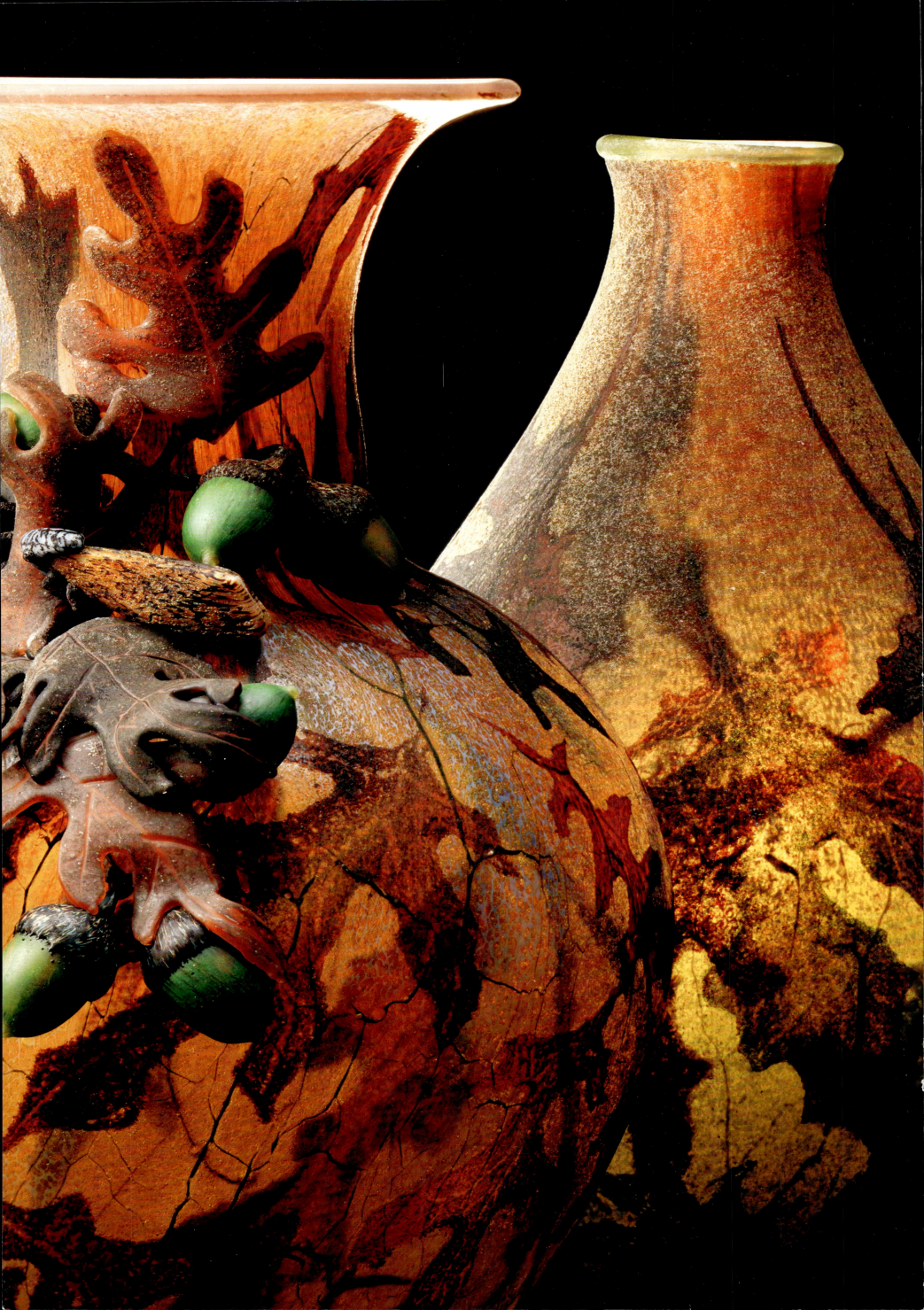

William Morris

Native Species

THE GEORGE R. STROEMPLE COLLECTION

William Warmus

BELZAR SPRINGS PRESS

PORTLAND, OREGON

In 1997, the Portland Art Museum organized *Chihuly: The George R. Stroemple Collection,* an exhibition that broke all attendance records for the museum and subsequently traveled throughout the country to both critical and popular acclaim. Making the *Native Species* series available through exhibition and publication is another example of how George Stroemple wholeheartedly embraces the opportunity to bring his collections forward into the public domain.

<div style="text-align: right">

Linda Tesner, Curator
George R. Stroemple Collection

</div>

Introduction

I met Bill Morris in 1991, not long after I started collecting the work of Dale Chihuly in earnest. At that time, Bill was just on the cusp of national recognition. I am struck now by how explosive his career has been — in terms of both artistic breadth and critical acclaim.

Our first meeting was at Bill's home in Stanwood, Washington, not far from the Pilchuck Glass School, where Bill uses the hot shop in the off-season. It was springtime. I drove up a long dirt driveway to an old farmhouse, where Bill greeted me at my car. Our paths had crossed briefly before, but this appointment had an air of potential — that of artist and collector.

Bill led me into a rickety old barn. Inside, light streamed through the slats of the walls against the dimness, making the interior of the barn feel like a cathedral and giving my mission an air of discovery. This was where Bill stored his work. Everything in the barn had just returned from one of Bill's first major shows, at the Brendan Walter Gallery in Santa Monica, California. On the ground, some objects still nestled in their crates, lids open so I could peer inside; others sat on low black risers — a setting completely unlike that of a rarefied commercial gallery. This was the first time I had seen an entire body of Bill's work. I immediately acquired eight objects from the *Artifact* series. At first just intrigued, now I was hooked.

Before we knew it, Bill and I had conspired to collaborate on a commission. Being interested in Egyptian artifacts, I proposed a series based on Egyptian funerary urns. I sent Bill a stack of photocopies of Egyptian designs from the library, expecting, I suppose, to drive the creative process a bit. Little did I know — nor did Bill — that those vessels would spawn the renowned *Canopic Jar* series (the items in my collection date to 1992). Soon thereafter I purchased *Cache* (1993), Bill's 36-foot-long installation of tusks and bones.

I am extremely grateful that what started as a collector/artist relationship has evolved into a genuine friendship. I'm not sure how often that happens between artist and patron. Bill and I began to enjoy spending time together, slowly introducing our families to one another. In my William Morris collection files, I've kept some mementoes from those times in the form of thank-you notes from Bill's kids, written in the shaky hand of primary-school penmanship.

Around the same time, Bill and I started going on motorcycle trips together, one time to the Alvord Desert in southeastern Oregon and the canyonlands of Utah, another to the Grand Canyon and the Southwest. I soon discovered that traveling with Bill requires a certain degree of surrender: Bill navigates by his own compass, and he knows exactly where he wants to go. Conversation was slight during the daytime — riding our motorcycles, we had little opportunity to chat. At night we camped and typically Bill took charge of the meals. He'd head into a grocery store and return with a choice cut of beef. Just as I began to salivate in anticipation of a grilled steak, Bill would cut it into chunks and boil it in water over the campfire, turning the meat into unappetizing grey cubes. I see now that taking

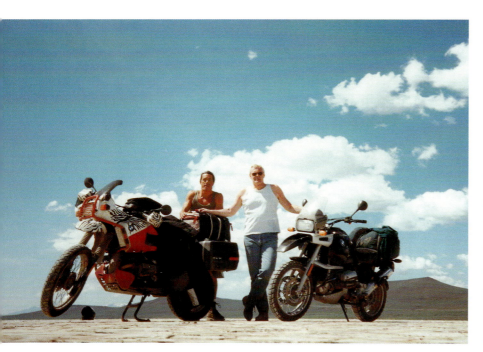

William Morris and George Stroemple,
the Alvord Desert, Oregon, May 1995.

these trips with Bill was an invitation into the mindset that informs all of Bill's artistic as well as life experiences.

Much has been written about Bill's lifestyle, how his sojourns in nature are equal and opposite to his time in the hot shop. Bill points out that he collects experiences, like ticking off the Northern Cascades peaks he has summited, or counting his spear-fishing dives, or paragliding or rock climbing or ... At only fourteen he felt completely comfortable in the woods, staying out alone several nights at a time. His repose as a solitary figure in nature is unusual – but something that Bill and I share. I see a lot of my own youth in Bill, such as when, just out of high school, I took off on my motorcycle and ended up at the Panama Canal. Eventually – as for most people – my responsibilities displaced spontaneous pluck. I admire Bill for crafting a lifestyle that allows him to do what he loves, both as an artist and as a man experiencing the world.

I have no doubt that our friendship, and shared respect for the profound beauty of nature, persuaded Bill to commit to this most recent commission, the thirty-eight vessels of the *Native Species.* We discussed my initial ideas for a collection of "natural history" objects at length – my own collection of Meiji ceramics, the admiration we share for nineteenth-century glass artists like Emile Gallé, our love of the simple artifacts that a walk in the wilderness can yield. Much of that discussion took place at my home near Steens Mountain in the southeast corner of Oregon, a place so remote from population that, when viewed from space at night, it is the darkest spot in North America. Between Bill's home in Stanwood and my ranches in Oregon, near Sisters and Steens Mountain, Bill had abundant familiar plants and animals from which to draw.

It's well accepted that when a collector commissions a body of work, the resulting artwork will never replicate the images rattling around in the collector's head. It has been my experience in collaborating with Bill that whatever he produces far exceeds my highest expectations. This is the case with the *Native Species.* I marveled in the hot shop as I watched some of these vessels take form, and I am still awed whenever I view this stunning collection. I could not have imagined the range of iconography and breadth of technical bravura that Bill manifested in these works. They remind me how much I appreciate my friendship with Bill, and the trust he has invested in our relationship.

It is particularly exhilarating for me to observe how two traditions of the nineteenth century – those of Japanese ceramics and French art nouveau glass – could be expanded by the work of this glass master more than a hundred years later. The *Native Species* eloquently evoke the past while simultaneously conjuring the present moment. These are souvenirs of a walk Bill and I might take in the desert. It is my hope that viewers will feel a similar connection with these works of art.

George R. Stroemple

William Warmus

*In the power of its artful foliations I saw a masterwork
crafted from grasses grown in paradise.*

— Marcel Proust, *In the Shadow of Young Girls in Flower*

Native Species originated with the collector George Stroemple, who
approached the artist William Morris with a proposal for a collabora-
tion. The idea was simple: both were familiar with the flora and fauna
native to Stroemple's ranches near Sisters in central Oregon and in
the Steens Mountain region of southeastern Oregon. Morris would
take this inspiration to his studio and make the species in glass,
using the vessel form to suggest their environments. Stroemple
also wanted Morris to think about how nature was seen in the nine-
teenth century, a period that actively interests him as a collector. He
admires, but does not collect, the work in glass and faience of the art
nouveau artist Emile Gallé, although he does have a significant col-
lection of nineteenth-century Meiji-era ceramics and bronzes, which
he made available to Morris. The French and Japanese approaches to
nature were different. Gallé is brooding and introspective; natural
forms sometimes appear to be melting into the surfaces of his ves-
sels, and he at times contrasts life and death on the same object; for
example, an orchid vase with a live orchid blossom on one side and
a dead or wilted specimen on the opposite side. By contrast, many
Japanese artists in the Meiji era produced bright and icy vessels,
with creatures standing out in clear and proud relief as if observed
in crisp and shining air. Not to be overlooked: the artists in this
book, from Gallé to Morris, used nature as their source. Theirs is a
dialogue with the natural world first, but the conversation they have
with each other about nature, by way of their work, also interests the
art historian.

Morris was charged by the twenty-first-century collector to air out
the musty nineteenth century, metaphorically dusting off Oriental
ceramics and French art nouveau vessels and bringing them once
again to life — in our era, a charge that resonates with the observa-
tion made by T. S. Eliot, in his mode as a critic: "Powerful art ages
and needs to be refreshed."[1] The name for the project, *Native Species,*
is a result of trying to find the right words to describe what Morris
created. While the term *native* applies to species that originate in
a specific region, it can also apply to a species that has been in a
geographic location for a very long time. Both definitions are valid
for the subject matter of these artworks. I think of *Native Species*
as steering a moderate course and striking a balance between the
ancient and the modern: the founding species and more recently
introduced creatures, seeking balance.

Why would Morris, whose work is in wide demand at galleries
and for museum exhibitions, and who seldom collaborates, under-
take such a project? There is a simple answer: The two men are
friends. They have known each other since 1991, when Morris was
an emerging artist. Stroemple first bought work from his *Artifact*

Native Species

series, including *Hunter.* This purchase led to the acquisition of additional work by Morris, and the sweep of the collection now includes work from the *Artifact* series, the monumental sculpture *Cache,* and the *Native Species.* Although collecting is for Stroemple a solitary experience, he enjoyed spending time with Morris, and they began to take motorcycle trips together, ranging through the West, from the Grand Canyon to Steens Mountain in southeastern Oregon.

Stroemple is interested in ancient Egypt and had been intrigued by canopic jars (tomb vessels used to contain the internal organs of the deceased) that he had observed in museums while traveling in Europe. At home on his ranch, he has a childhood collection of bugs and snakes, badger feet and rattlesnake heads, scorpions and black widow spiders, which he keeps preserved in jars of formaldehyde. The jars on the ranch in the American West and the jars in the tombs from Egypt were compelling, and this led him to the library for more research. And then, quite simply, he asked his friend Morris to make some contemporary canopic jars. But that is another story. A decade later Stroemple again approached Morris, with the idea for the *Native Species.*

16

I love flowers fashioned of glass or gold,
genuine gifts of a genuine Art
dyed in hues lovelier than natural colors...

— C. P. Cavafy, "Artificial Flowers"

Morris is among the few contemporary artists who could undertake a project like *Native Species.* Glass is a demanding medium, and convincing realism in glass is difficult to accomplish. The earliest substantial glass objects, c. 1500 BC, were vessels created in the Near East. But it was not long before glassmakers contributed to the realistic portrayal of the human form: the golden mask of King Tutankhamen (c. 1327 BC), including the eyes and the outlines around the eyes, is inlaid with semiprecious stones and glass. Without the inlays, the mask would lose much of its intrinsic appeal: the stone-like quality of the glass frames and anchors the ethereal shine of the solid gold matrix. Around this time, the first cast-glass sculptures also appear, taking human and animal form. And when glassblowing was invented, again probably in the Near East in the first century BC, glassblowers often sought to portray human and animal

William Morris, *Artifact: Hunter (no. 3),* 1988, glass; 10 × 48 × 122.

William Morris, *Canopic Jars: Falcon, Jackal, Baboon, Human,* 1992, glass; 23 × 11¾ × 11¾ to 29 × 12 × 12.

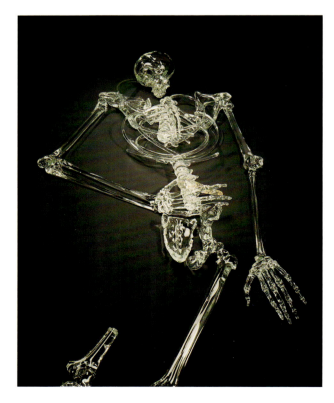

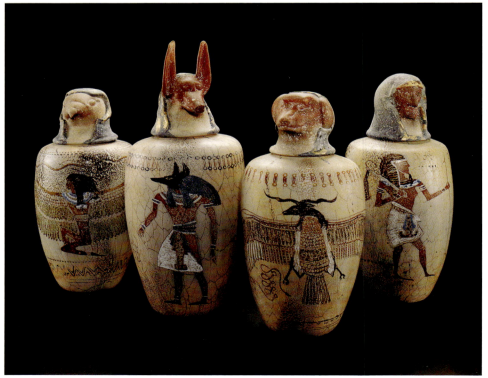

The Place of Art

If only it were easier to look at fine art. If only we could display the art we find beautiful in our homes, where it would be available every day. Experience proves otherwise. Some art is too rare, owned only by museums. Some is simply too big, or too deeply hidden, or too hard to find. The staircase that led down to Tutankhamen's tomb in Egypt was filled with tons of stone debris and forgotten for over a hundred generations. In twenty-first-century Portland, where I will examine the *Native Species,* there is a warehouse, which is reached on foot by crossing a bridge over the Willamette River and descending steps to the industrialized area of southeast Portland near the Hawthorne district, an area haunted by the memory of Italian produce distributors. On a street now shadowed by a concrete and steel overpass, the warehouse is one among several buildings of no special quality – an unobtrusive, secret hiding place in a neighborhood of warehouses, the closest restaurant a twenty-four-hour diner. There is absolutely nothing distinctive about this place. That is its attraction.

I meet Linda Tesner, the curator of the Stroemple Collection, who produces a brass key that unlocks the first of a series of doors leading into storerooms. Once inside, she moves to turn on the overhead lamps, which come to life slowly and emit an amber sodium-vapor glow. On a white and gray plastic keypad, engraved with the single word FOCUS, she enters the code that shuts off the alarm system. The overhead lights, now hot and bright, reveal a large L-shaped room that is full almost to the rafters with solid-looking crates. A closer look reveals that all the boxes have photos affixed to their blank faces, and labels, indicating that these cartons contain objects that are distinctive and unusual and quite rare. This room is a special place, holding works of art. Impressions matter inside this room, because that is all there is here: works of art that must be experienced.

The art is unpacked for me as I set up my workplace. I anticipate that the experience will come with a mild tension. These objects are made from glass: delicate and powerful, strong and brittle. They may not be meant to intimidate, but they do intimidate because they are so valuable and yet so delicate. I have spent most of my life handling glass: there is invariably an edginess to the process. We give it wide berth, as if glass, because it is so fragile, takes up more space than other media.

As the art handler, John Black, populates the tables with the glass, I see that Morris has made a series of vessels unlike his previous work; these are perhaps his most subtle and intricate creations. The contradiction comes down to this: to experience them, I must hold them in my hands and look at them as closely as possible, almost as if they were jewels. But they are larger than jewels and they are fragile. Some are tall and thin and rest on small bases. I shrug my shoulders: this is the exquisite character of glass. And then everyone leaves. I am locked inside this chamber for hours each day. There is no sound from the outside and the concrete floor is softened by two large rust-colored Oriental carpets. I have a folding table on which to work. Around the perimeter of the room are five more folding tables, each covered with a green felt blotter. Arrayed on these tables are the *Native Species,* about three dozen of them. The overhead track lights are intensely white halogen spots and floods. There is a smooth, velveteen sound of the continuous flow of air into the room. An interrogation chamber for art? Perhaps. At times more like a monk's cell. Some days I decide to forgo food, as if fasting. At times I daydream, lulled by the atmosphere of the room and the subtle art it protects.

In Nature

By choice, Morris leads an insular life in the country; his preference is to go without television or the Internet. "Nature," he says, "is the most genuine voice I hear. I am a product of nature, although I do not think of myself as an environmentalist. . . . The modern world is about thinking, but (for example) when I'm free diving, I am not thinking. You can't think your way into that place."

"And glass?"

"Glass is not high technology. It is a primordial substance."

"So why deny glass its shine in much of your work?"

"Shiny glass denies form — look at your eyeglasses — they mask rather than reveal."

Of the *Native Species* vessels he created for Stroemple, Morris says, "It is the first substantial body of work I have made with two and three layers of glass. Beyond the challenges and subtlety of the technique, I wanted the immediate impression. If you ask 'What kind of bird is that?' I have failed."

"The central focus of my life is nature. And George gets it: humility in front of nature. If you don't use a line of communication it becomes rusty. How clumsy we have become with the natural world. Most people, when a leaf falls, seldom stoop to inspect it. For me, hunting is a part of nature, it takes me into nature."

"Right now I am looking at a lenticular cloud over Mount Rainier, as opposed to what I am thinking about and talking about on the phone with you. So when you ask me about the environment, I have to say that feeling disheartened about the destruction of nature won't help. I want to be in nature." Morris ends our transcontinental phone conversation by reminding me, kidding me really, about a walk we took through the desert in Arizona, years ago, at night, when I was afraid of the dark.

Origin of *Native Species*

In commissioning the *Native Species* and suggesting that Morris look at the work of Emile Gallé, Stroemple was thinking of Gallé the naturalist, who wrote: "The love of the flower reigned in my family: it was hereditary passion. It was salvation."[11] After his death, Gallé's widow noted that if he had renewed the arts, it was because he had "studied plants, trees, flowers, both as an artist and a scholar."[12] Gallé surrounded his glass factory in Nancy, France, with gardens, and he assembled natural history collections for use in the studio. Nature, transmuted under his careful direction by the techniques of a skilled glassmaking team, became art. In 1889 Gallé wrote that to incarnate his dream he sought "to dress crystal in tender and terrible roles. . . . to order technique in the service of preconceived works of art." All this while risking the "hazards of a craft in which fire collaborates."[13]

Emile Gallé died in 1904, having created artworks that "would seem one day to have lived in their own time."[14] In the hyperrealistic way in which they incorporated nature and through their use of symbolism, his greatest works lived in the art nouveau era. For example, in 1900 at the Paris Exposition Universelle, he exhibited a vase emblazoned with a bold thistle, for Gallé a patriotic symbol of the French region of Lorraine, where he lived and worked. It is perhaps surprising that some very intriguing works by Gallé found their way ultimately to the Pacific Northwest and entered the collection of the remote Maryhill Museum of Art, which is about one hundred miles from Portland, Oregon, near Goldendale, Washington, and located in terrain that is rough and arid like the Steens Mountain region.[15]

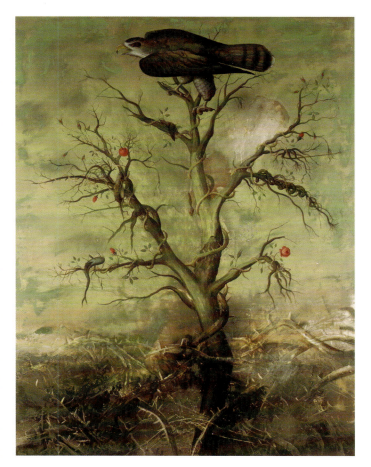

Alexis Rockman, *Territorial Display*, 1989, oil on canvas; 96 × 72.

Among the Gallé artworks at Maryhill are the *Corncob* vase, the *Vase with Butterflies,* and a vase depicting eagles amid wild mountain peaks. All were the gift of Alma de Bretteville Spreckels, one of the museum's founders, who learned about art nouveau firsthand from the dancer Loie Fuller when she met her on a buying trip to France in 1914. In their refined sense of drama and refinement of technique, these vessels show a sensitivity that looks beyond art and attempts to convey as directly as possible the artist's intimate and unmediated impressions of nature.

A precise one-hundred-year interval separates the death of Gallé from the creation of the *Native Species*. Nature continues to inspire us, but her symbolic value is, of course, different. In 1892, Gallé created the *Pasteur Coupe,* an "inoculated" glass vessel, symbolically infected with formidable microbes, in honor of the seventieth birthday of Louis Pasteur and his "fertile doctrine of germs."[16] In 2006, as our understanding of nature deepens and becomes more precise, we seem, in contrast, to be distancing ourselves from nature in our everyday lives. We inhabit a world where the molecular structure of Pasteur's germs can be decoded, and simultaneously, a world where nature is popularly caricatured and cartooned by artists who create cuddly creatures like Bambi and Nemo. Our relationship to nature has never been deeper or more superficial. You might say that we have learned that nature is negotiable: flexible, navigable, open to modification – something hunters have known for eons.

Morris and Stroemple may have set out at first to collect some sample specimens from the areas where they live and to memorialize these in glass, but they have also literally westernized Gallé and Japanese art. They collected specimens, such as pine needles and acorns and scorpions, from three different ecologies in the American West: Washington state north of Seattle, Sisters in central Oregon, and Steens Mountain in southeastern Oregon. Morris and his team adapted Gallé's techniques to the vernacular of the modern artist's studio. This process is not unlike Gallé's careful attention to the facts of nature and the techniques of making art, but the results are uniquely of their location and time. In the *Native Species,* in its fusion of the vernacular of the American West, the clarity inherent in Japanese ceramics and the compelling prowess of American studio glass, Morris has created artworks native to America.

Fact cannot corrupt taste.... The real corrupters are those
who supply opinion or fancy.

– T. S. Eliot

The thirty-eight vessels in *Native Species* are the founding facts of this series. Moving beyond the warehouse, past the biographical details of Morris and Stroemple, through the aspects of nature that inspired the commission, and emerging at the furnace where they were forged and tempered, we are prepared again to experience the artworks. There are some obvious limitations. For example, in all my work I have never seen any of the *Native Species* in daylight. Compensation for viewing them in the warehouse is that I am able to touch them and hold them in my hands and look inside the vessels, literally, through their openings. But daylight is denied me.

How should we negotiate the *Native Species?* We might want to wander among the vessels as you would through a field filled with different species of plant and animal life. This could be in the wide-open and highly dramatic spaces of the Steens or in an urban park

or in a museum. Wandering is nice because it is how we tend to approach nature. We have a trumpet vine on the side of our home; every spring it grows as if in a rain forest, and by fall it must be pruned and tamed before it overwhelms the entire house. As I prune I discover the remains of summer life: hornets' and birds' nests, even the occasional black snake that has taken up residence. Pruning need not be an especially directed or organized process; you follow the thick and woody stems, and they lead you to the parts that can be pruned, and then the wispy parts that can be pulled out by hand. This mixture of a plan (pruning) and distraction (discovering the snake) is how I think we might approach Stroemple's commission. It is perhaps a suburban approach to nature, but although *Native Species* was made by a hunter and inspired by a hunter/collector, it is intended for viewing by a generalist audience more accustomed to pruning and arranging flowers in a vase.[17]

◇ ◇ ◇

So inspect and enjoy this world: It includes antelopes, cedars, oak and maple leaves falling in autumn, a grove of aspens and a stand of poplars, dragonflies and wild grasses, ring-necked pheasants, Canada geese preening, California quail amid seedpods, a somewhat alarming collection of carrion, intricate pine cones and needles, berry bushes, beetles and centipedes, lizards and desert artifacts, and sleek and curious ground squirrels.

And enjoy too the rarity of this world. Everyday mass-produced vases might be used to hold a bouquet of flowers. But the *Native Species* vessels are not everyday vases. They are magical, although magic is seemingly everywhere discredited as a trickster's craft. You might regard any one of these vessels, for example the *Wild Grass* vase (no. 1, p. 69), as if it were an unembellished object set down in an open field of wild grass. Imagine that it then absorbed the impression of the grass into its surface before being taken back to the warehouse. This is perhaps a dreamy way to describe what in reality happened: Morris hiked with Stroemple through rugged mountain and desert terrain, absorbing impressions. He then brought specimens and his impressions back to the studio and at the furnace performed alchemy or magic: the glass absorbed the wild grass through his skill. Alchemy and magic, by the way, should perhaps be

Emile Gallé, *Corncob Vase*, c. 1900, glass; 13 × 3½ × 2½. Maryhill Museum of Art, Goldendale, Washington. Gift of Alma de Bretteville Spreckels.

Emile Gallé, *Vase with Butterflies*, c. 1900, glass; 15 × 7 × 7. Maryhill Museum of Art, Goldendale, Washington. Gift of Alma de Bretteville Spreckels.

Emile Gallé, *Mountain Crags with Eagles*, c. 1900, glass; 10¼ × 4 × 2½. Maryhill Museum of Art, Goldendale, Washington. Gift of Alma de Bretteville Spreckels.

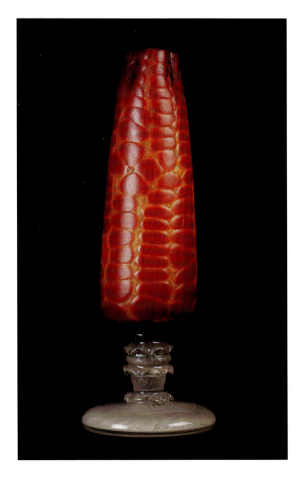

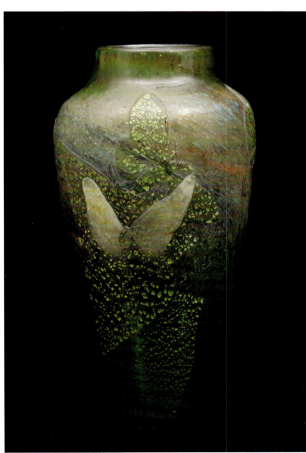

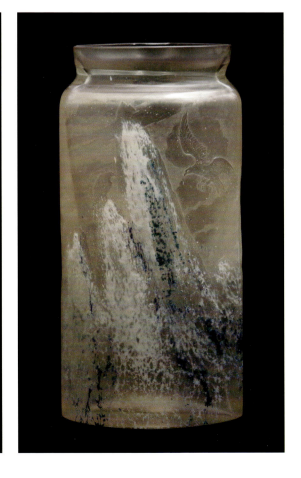

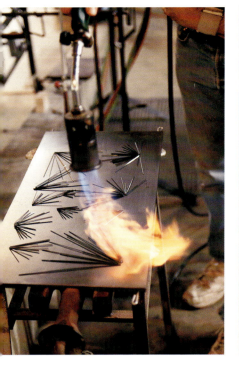
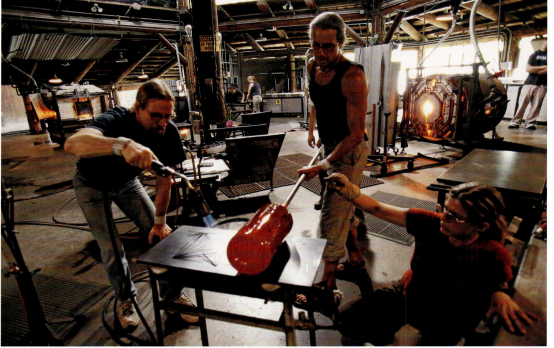
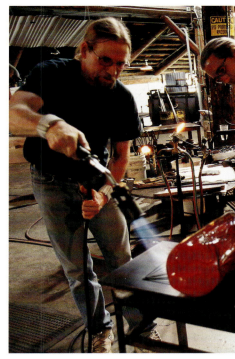

considered branches of science that are underrated today because they were overestimated in the Renaissance. Alchemy is not about turning lead into gold. It is about turning glass into grass.[18] In making *Vase with Wild Grass (Green)* and all the others, wizardlike skill was essential. There are today thousands upon thousands of artists making glass in studios, and many draw inspiration from nature. Nature has once again become fashionable in the art world. Among American glassblowers, Morris is probably the best. His skill and his ability to assemble a skillful team allow him to navigate between technical jargon and artistic cant in order to create meaningful art that leaves an impression upon the viewer.

Evolution of *Native Species*

Morris makes his work in the hot shop at the Pilchuck Glass School. Furnaces there contain fiery orange batches of molten glass, glory holes for reheating the glass, and annealers that cool finished works slowly to relieve stresses that have built up in the glass. Blowing glass requires a team, including Morris as the gaffer (the glassblower in control of the team) and Jon Ormbrek, adept at interpreting Morris's sketches and translating them into images made from powdered glass (also called sand or frit drawings), which are fused into the vessels. Randy Walker and Karen Willenbrink assist Morris in the hot shop, and Rik Allen engraves and cuts the work after it has been annealed. The tools in the hot shop include blowpipes, punty rods, puffers, crushers, jacks with round or teardrop blades, put-away tongs, shears, paddles, pipe brushes, and yokes. The gaffer works seated at a bench or standing at a marver table – a small table with a thick steel top upon which the molten gather of glass, at the end of the pipe, can be rolled and shaped. Glassblowing requires the artist to become adept at recognizing and balancing extremes of temperature. In order to work the glass, it must be molten, but more like taffy and less like honey – if it is too liquid it will flow off the blowpipe. The gaffer works the glass on the pipe and reheats the glass in the glory hole. At the bench, Morris might use compressed air to cool a section of the emerging artwork or a blowtorch to heat the mass of glass. Shears or scissors may be used to cut away parts of the molten glass; graphite paddles can be used to shape the glass, as can wet newspapers pressed against the molten gather of glass as it is rotated.

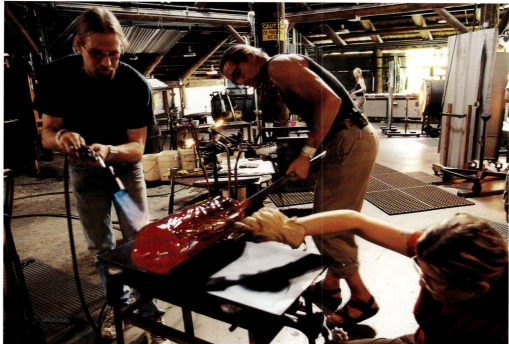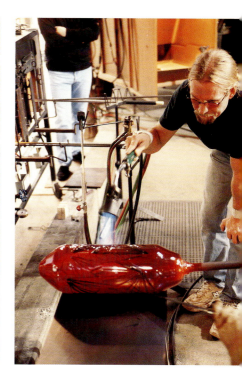

Bits of glass may be shaped and added to the emerging molten vessel; for example, a gobbet of glass may be shaped into a smooth acorn, decorated with crushed-glass colors to mimic the rough texture of the acorn's cap, and then applied hot to the vessel. This process is repeated over and over again if the vessel is to display an intricate leaf and acorn relief (as in no. 25, pp. 40-41).

Multiple layers of glass introduce a richly textured atmosphere into the *Native Species.* The ancient Romans created cameo glasses when they cased (covered) a bubble of deep blue glass with white glass and then, when it was cold, cut back the white to create marble-like figures against a lapis-blue ground. Gallé used a rich variety of casing and layering techniques in his important, complex, and costly creations. The most prominent of the layering techniques developed since Gallé's work is called the "graal [as in Holy Grail] technique." Associated with Swedish glass factories, especially Orrefors, it was inspired by Gallé, who had exhibited his work in Stockholm in 1897. The Scandinavians saw Gallé's most imaginative creations as arcane, frenzied, even ugly, and graal glass was a moderated and simplified reaction to his perceived excesses. In the *Native Species,* Morris revived and extended the technical traditions of Gallé and Orrefors, as well as those of other art nouveau–era artists and factories including Daum.

The result of this mingling of techniques is Morris's ability to create a rich vessel wall, to create, using Gallé's word, an inoculated glass. Although many art mediums allow the artist to capture minute detail, glass, because of its transparency, is among the few substances that allow the artist to sculpt detail inside the mass of the material and have it visible. When glass is also layered, the sculpting takes advantage of an artistic decision-making process about how much of the interior to reveal and how much should remain concealed.

In the *Native Species* we encounter three types of sculpting. Jon Ormbrek does his work before the hot glass is gathered, creating glass frit drawings that are encased within the walls of some of the vessels with, for example, shadowy leaves apparently floating in space (see no. 10, p. 106). You know that these leaves are trapped within the glass because your hand cannot touch them. In other vessels, the leaves are on the surface and, if you run a fingertip over them, you'll feel their fritty, sandy texture. Rik Allen sculpts after the glass has cooled, with a handheld engraving tool, such

Second from left (left to right): Randy Walker, William Morris, Kelly O'Dell.

Middle (left to right): Randy Walker, William Morris, Rahman Anderson, Kelly O'Dell.

Second from right (left to right): Randy Walker, William Morris, Kelly O'Dell.

Right: Randy Walker.

Native Species

38

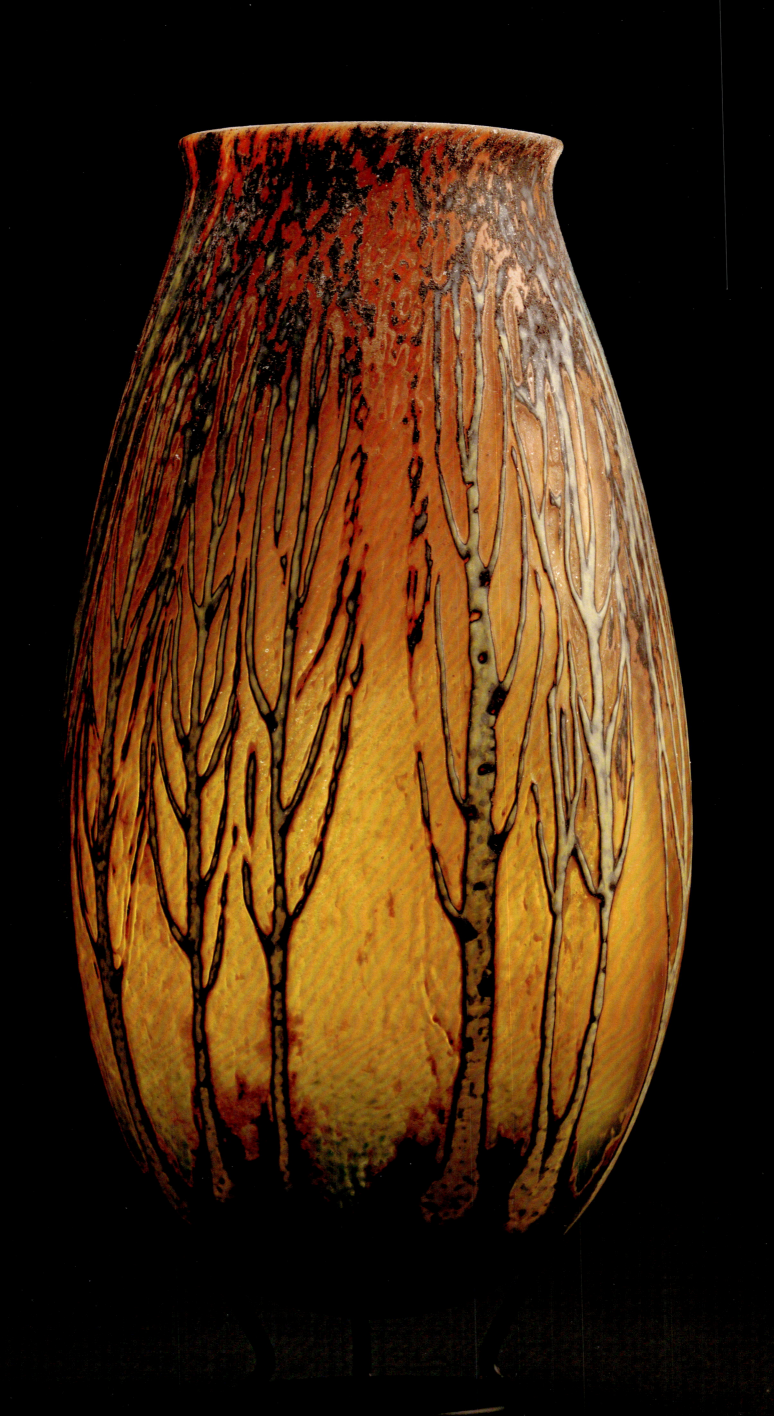

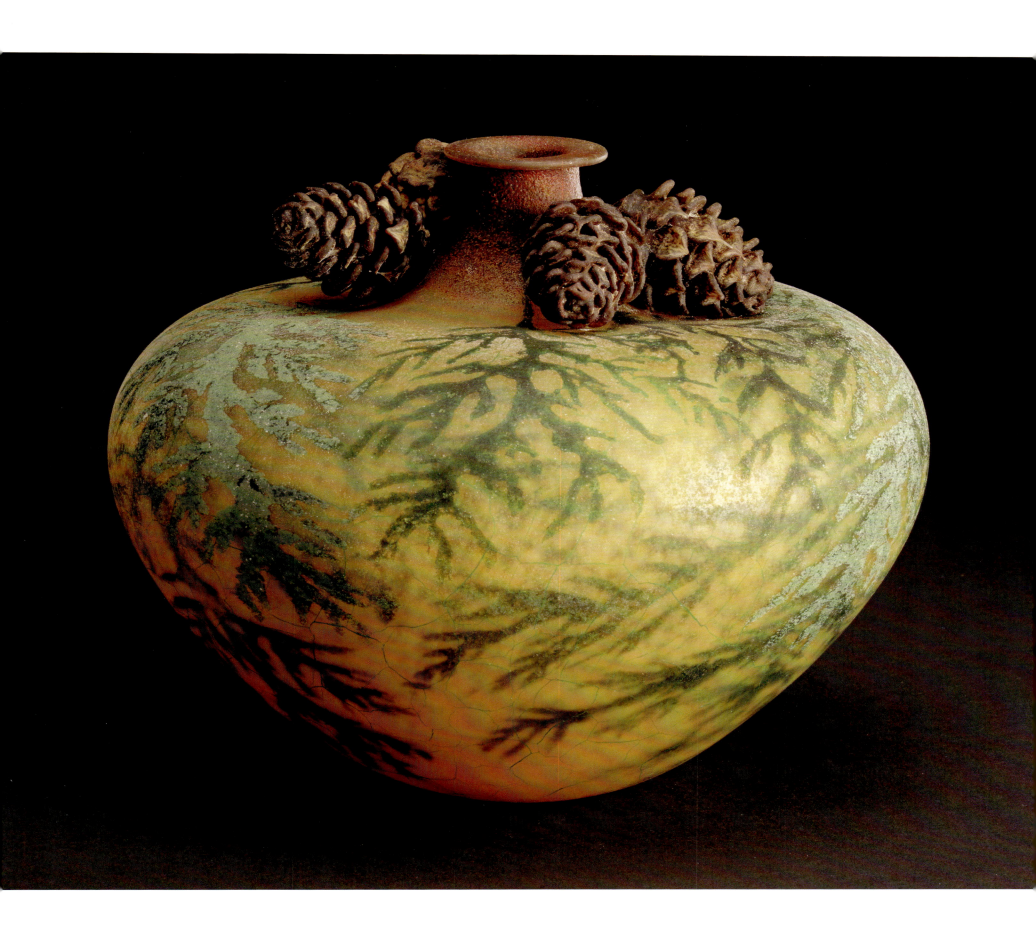

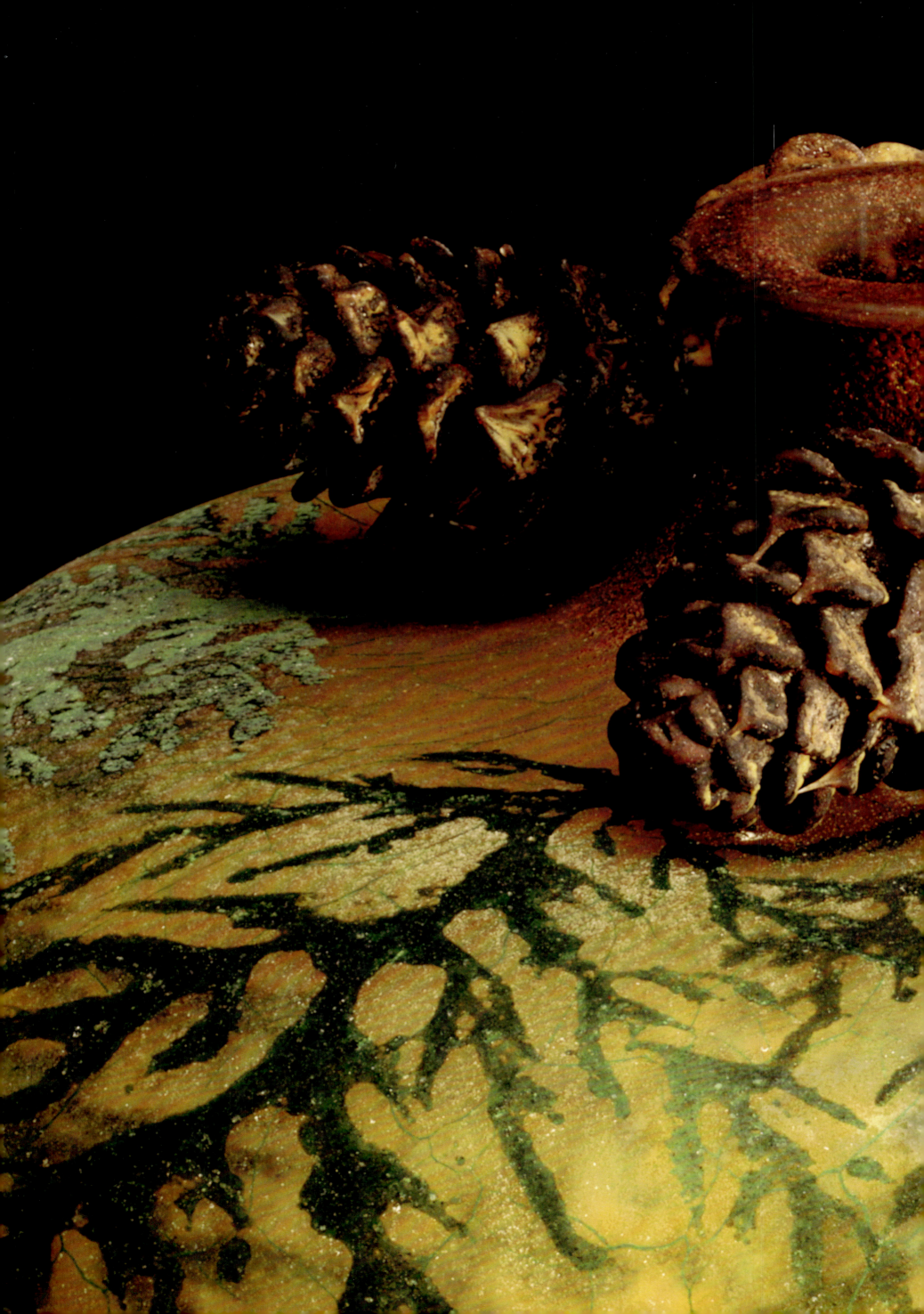

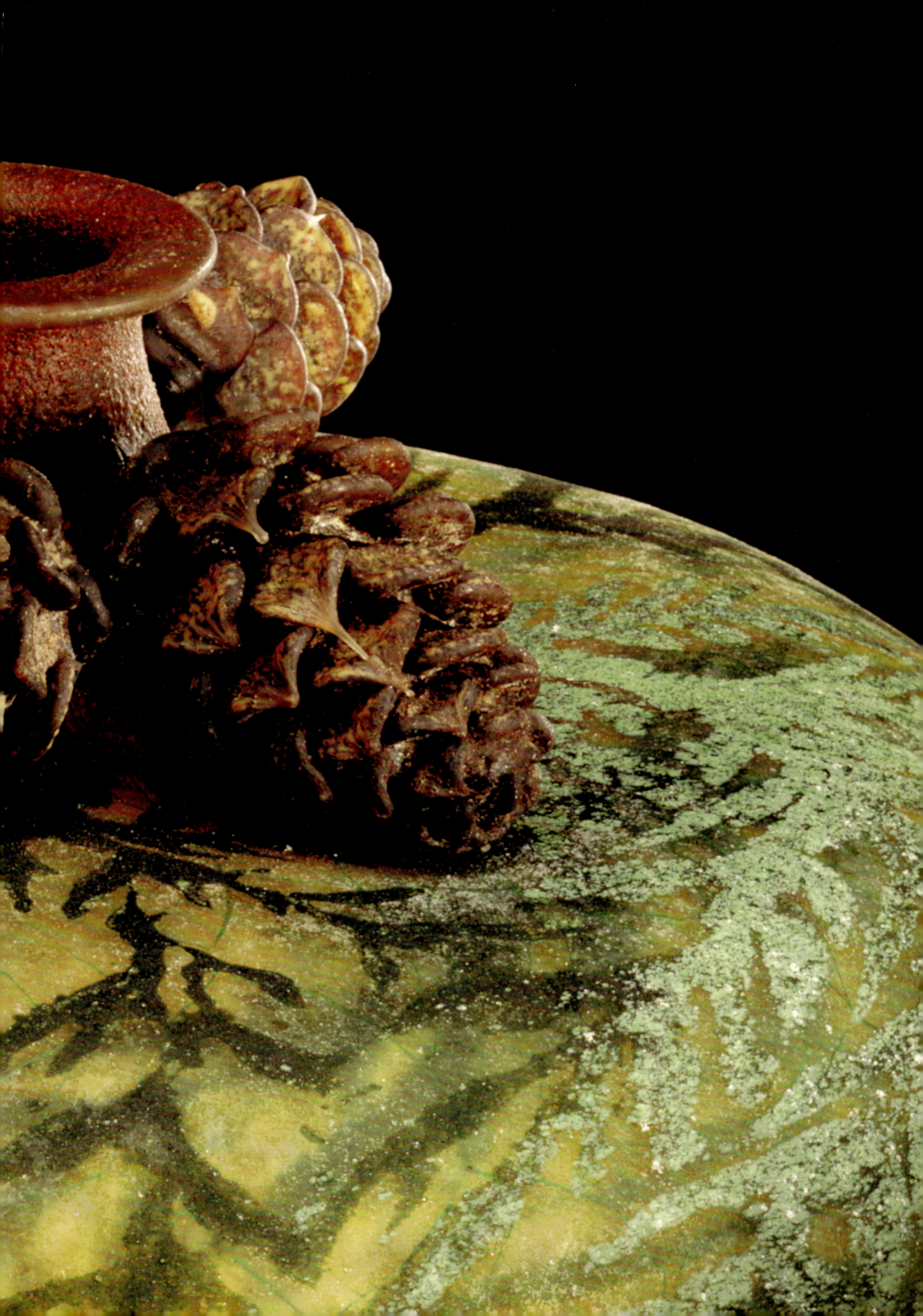

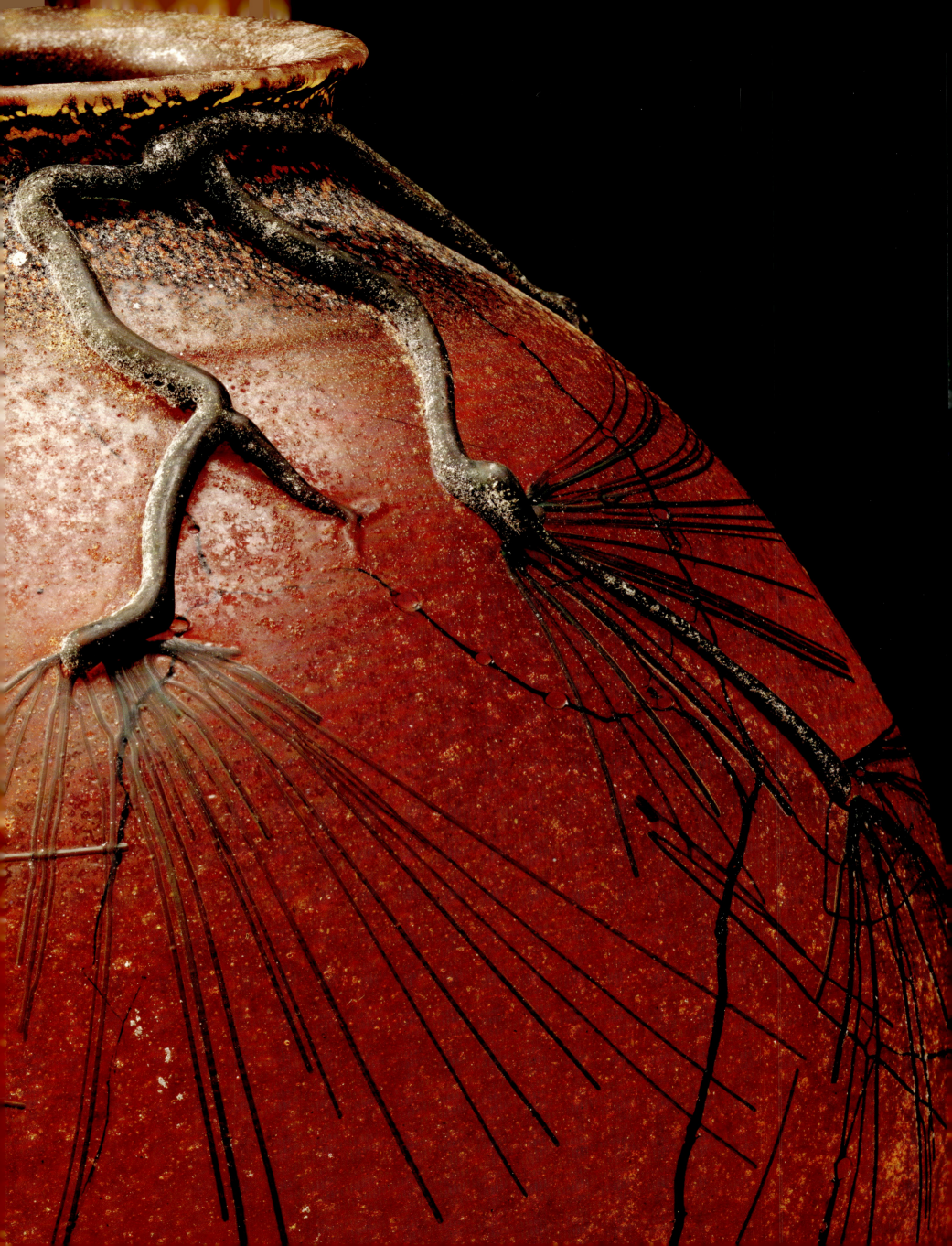

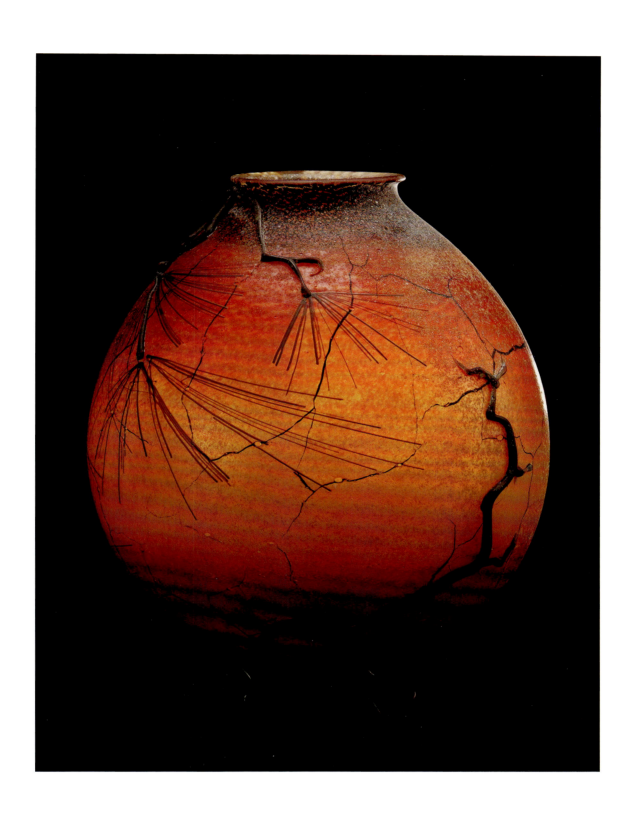

NATIVE SPECIES: GLOBE VESSEL WITH PONDEROSA PINE BOUGHS

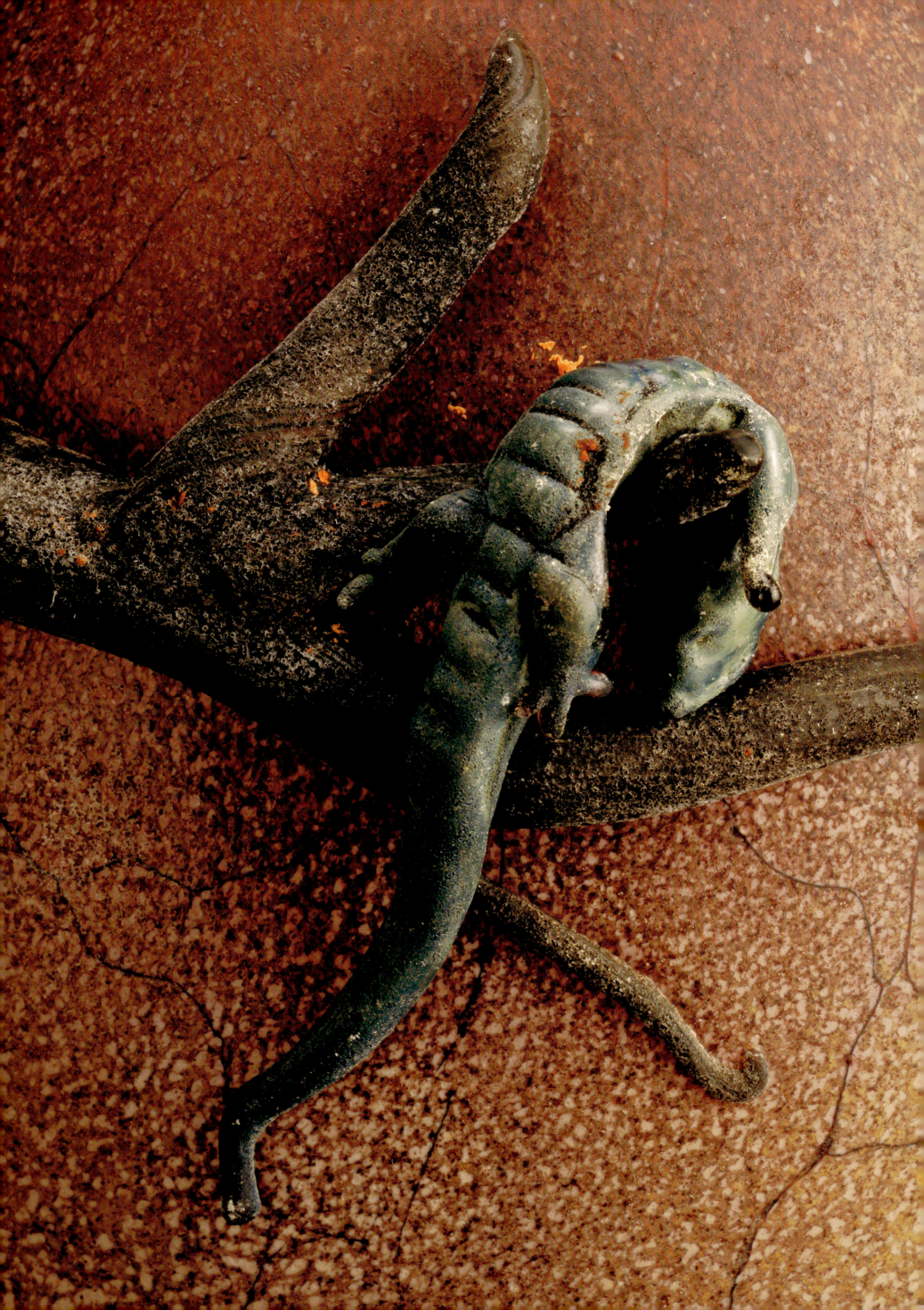

52

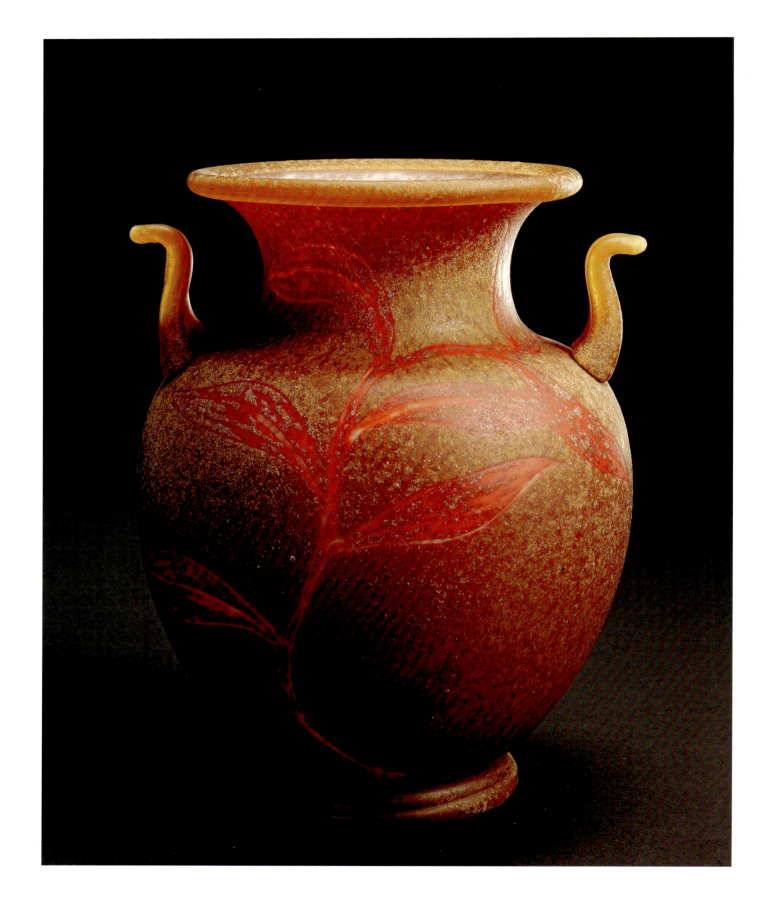

5 NATIVE SPECIES: STAMNOS WITH ENGRAVED VINE

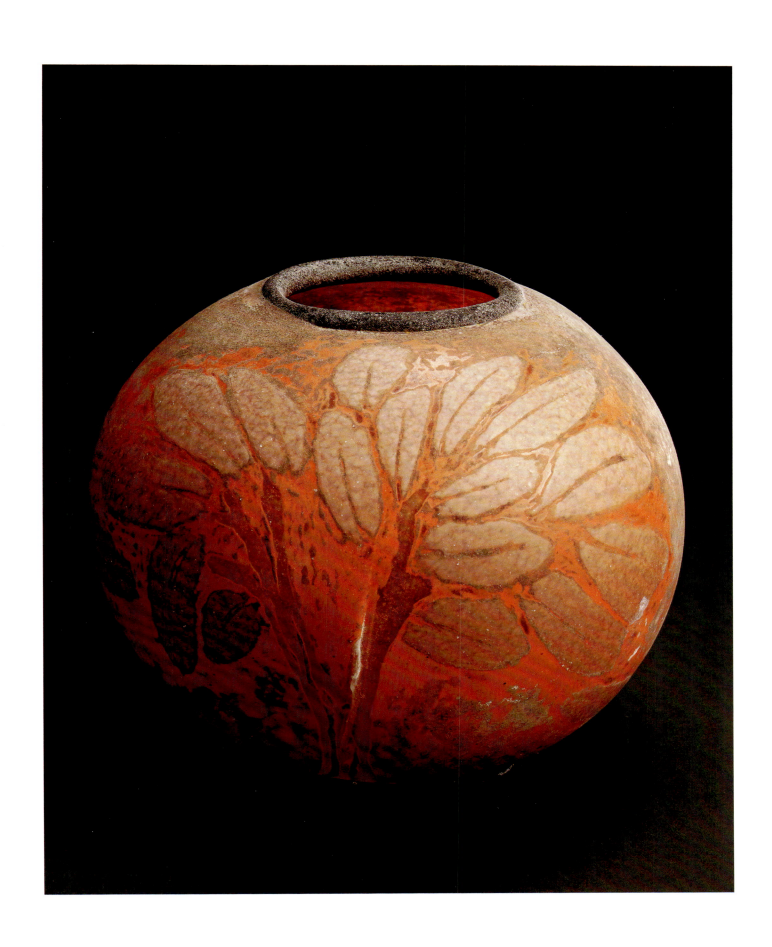

NATIVE SPECIES: GLOBE VESSEL WITH LEAVES

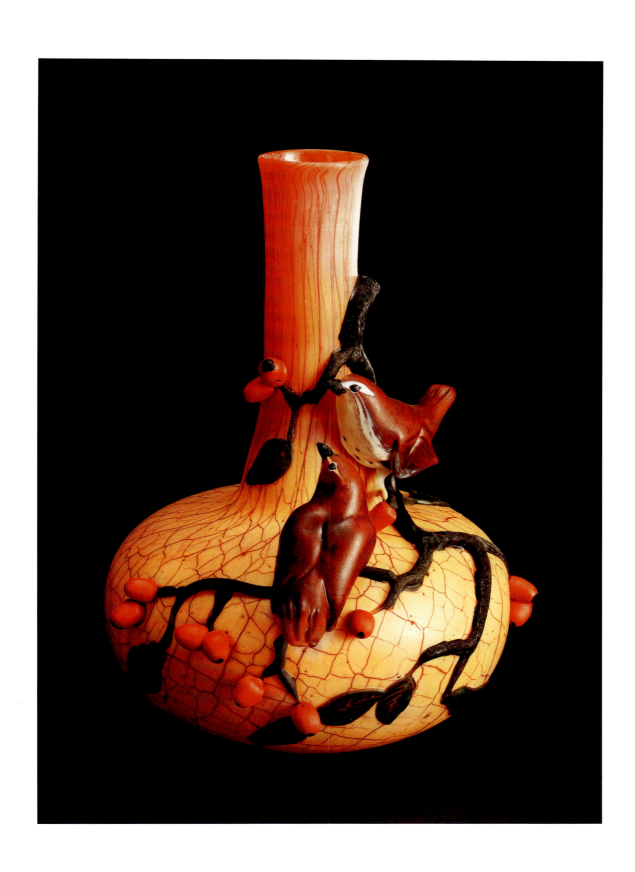

NATIVE SPECIES: LONG-NECKED VASE WITH WRENS AND BERRIES

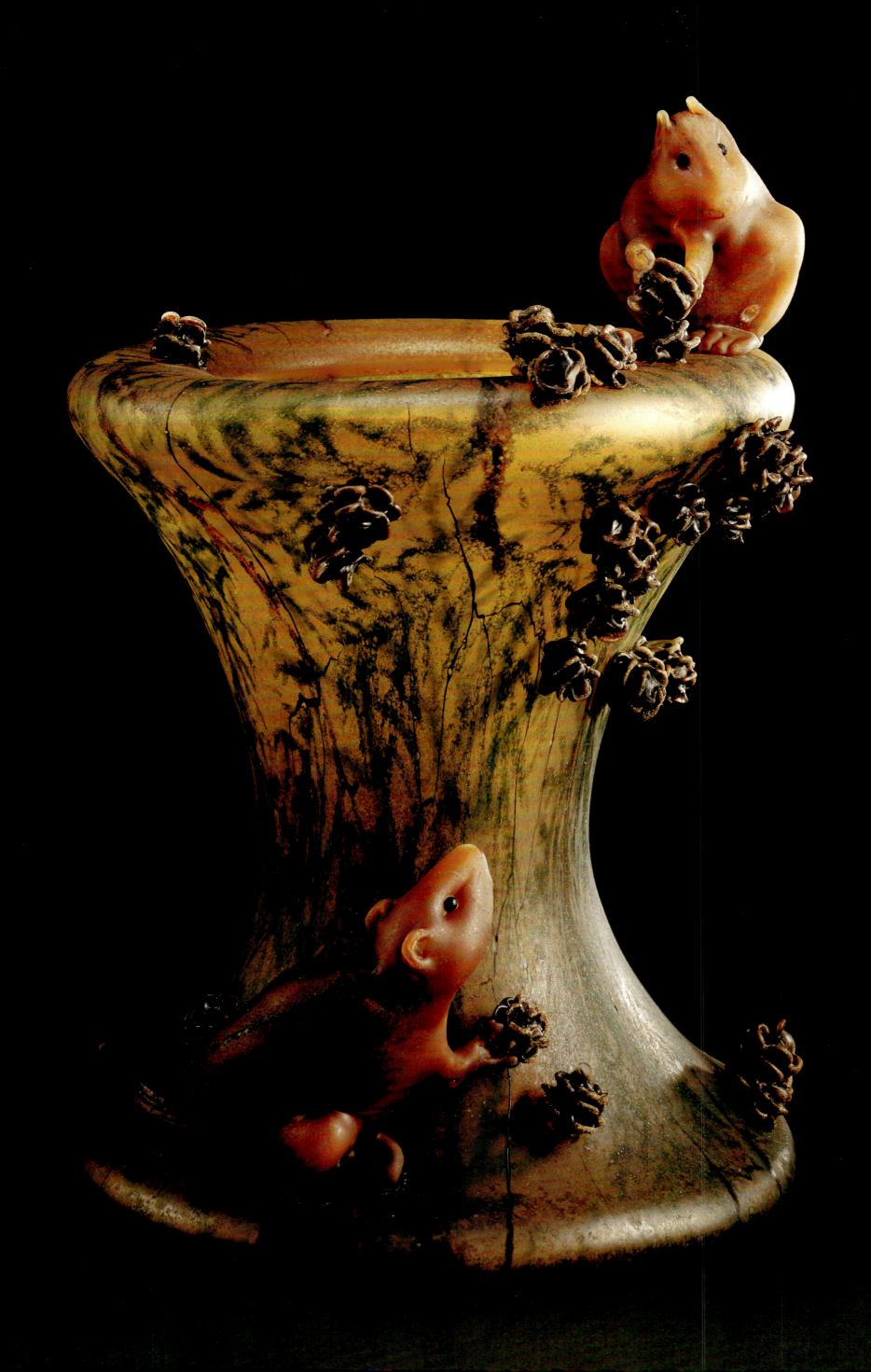

NATIVE SPECIES: VASE WITH CEDAR BOUGHS AND GOLDEN-MANTLED GROUND SQUIRRELS

60

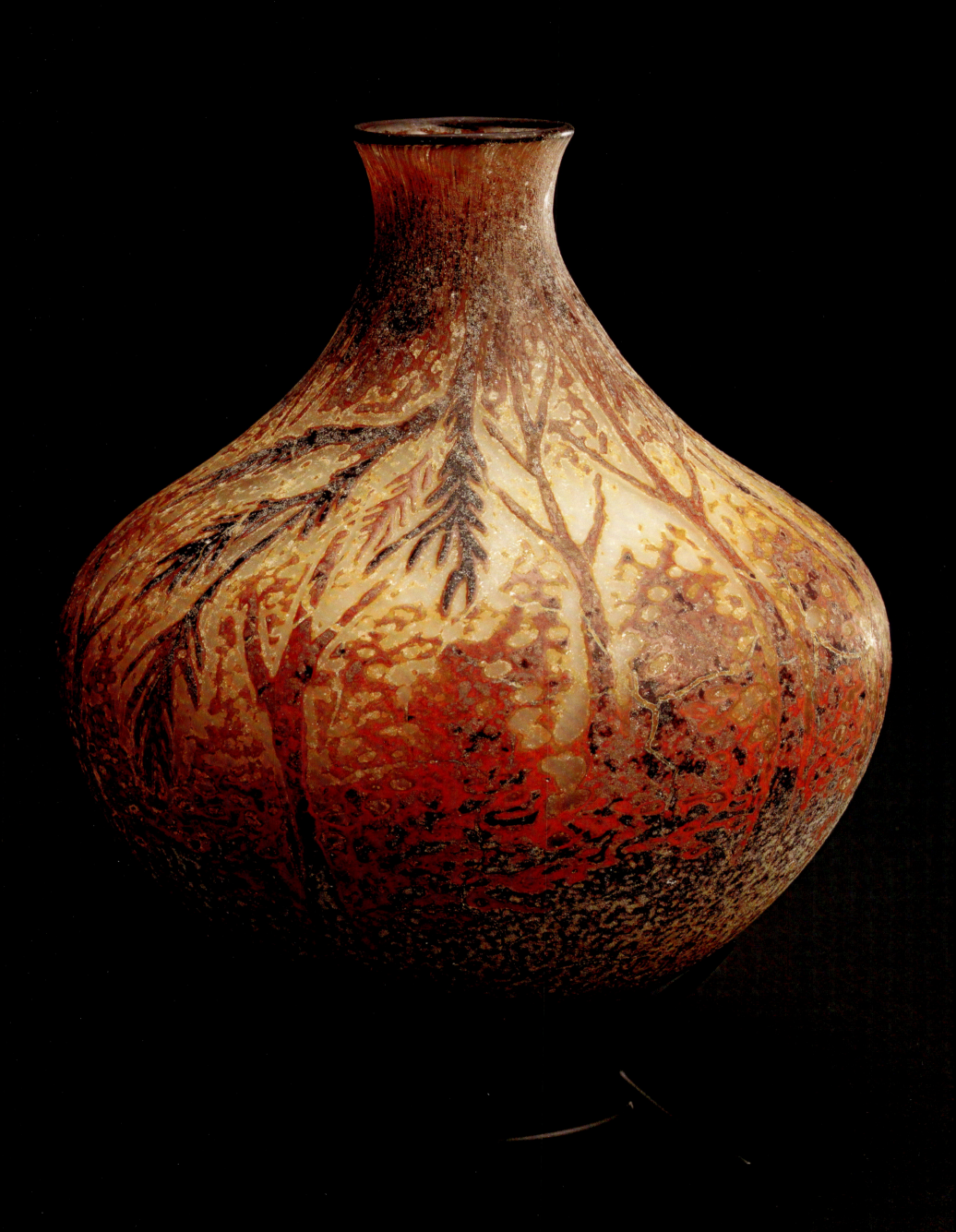

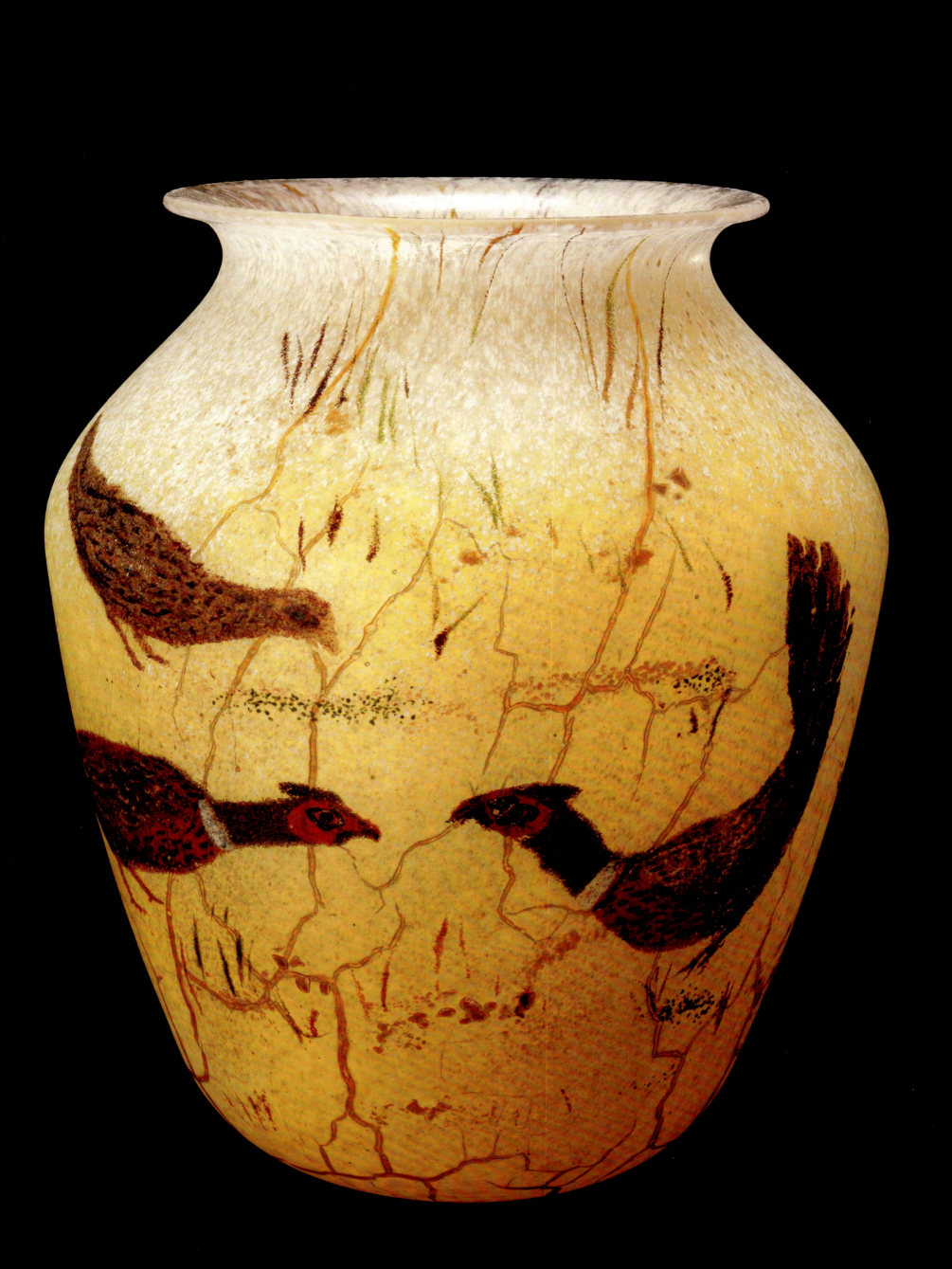

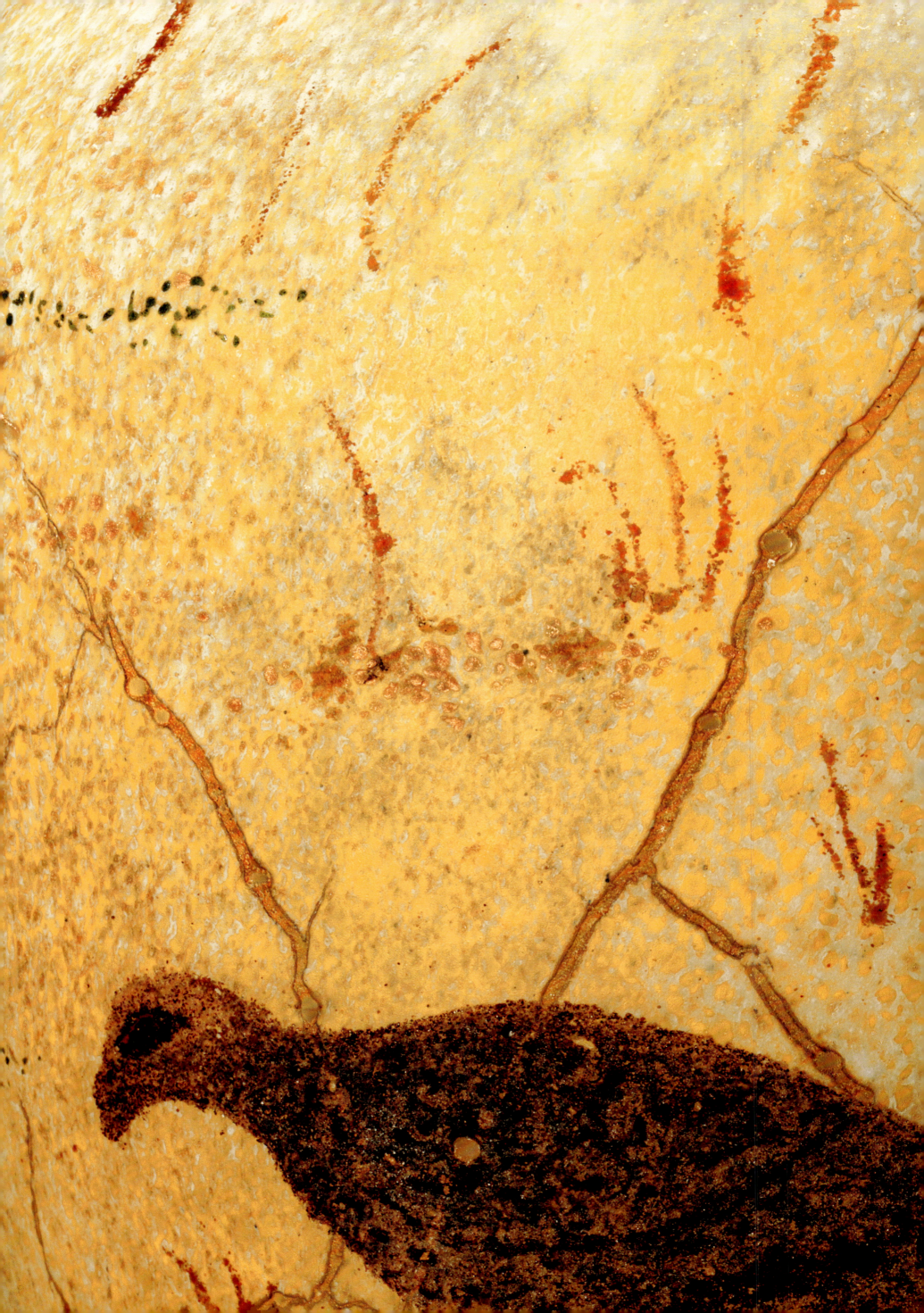

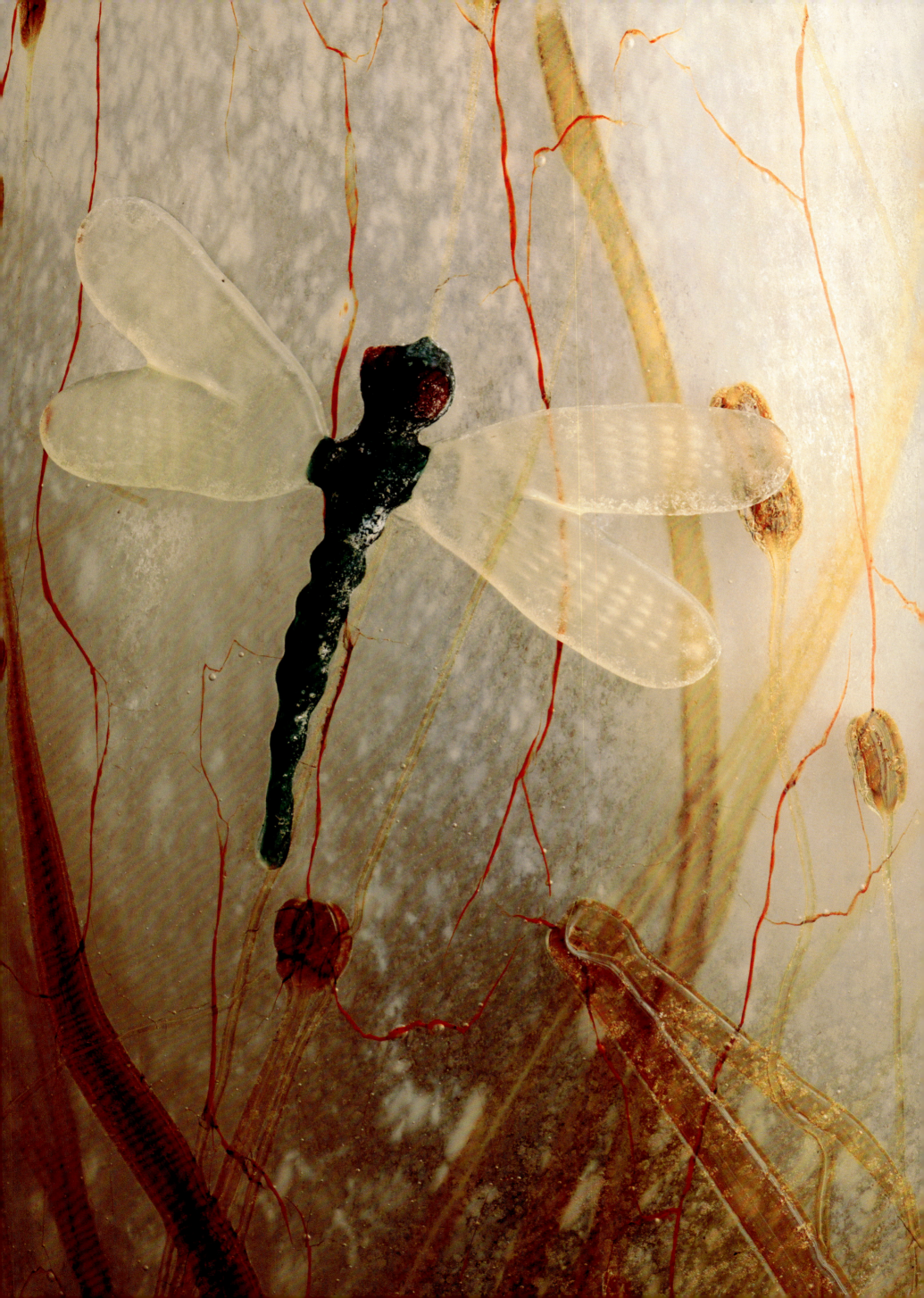

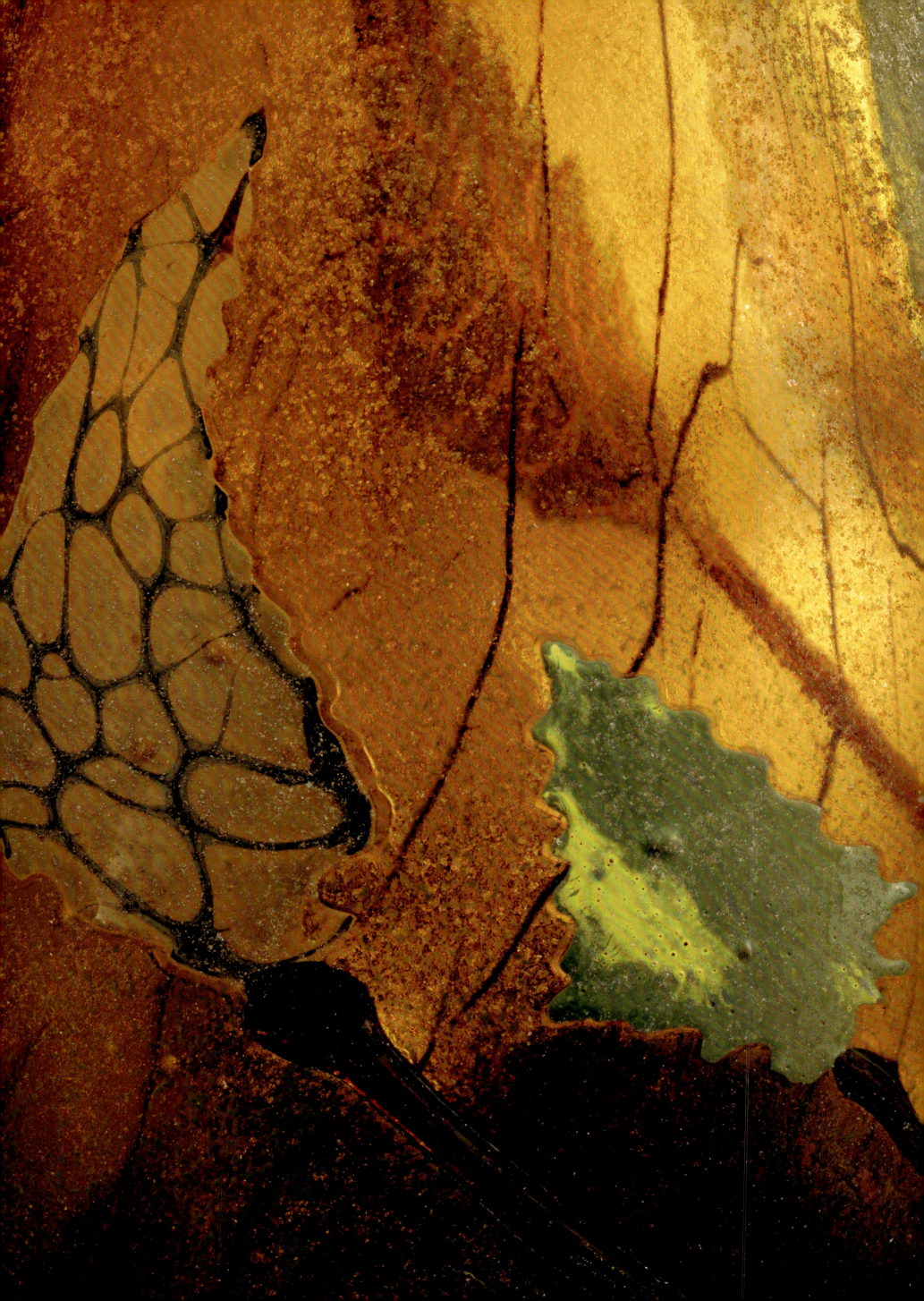

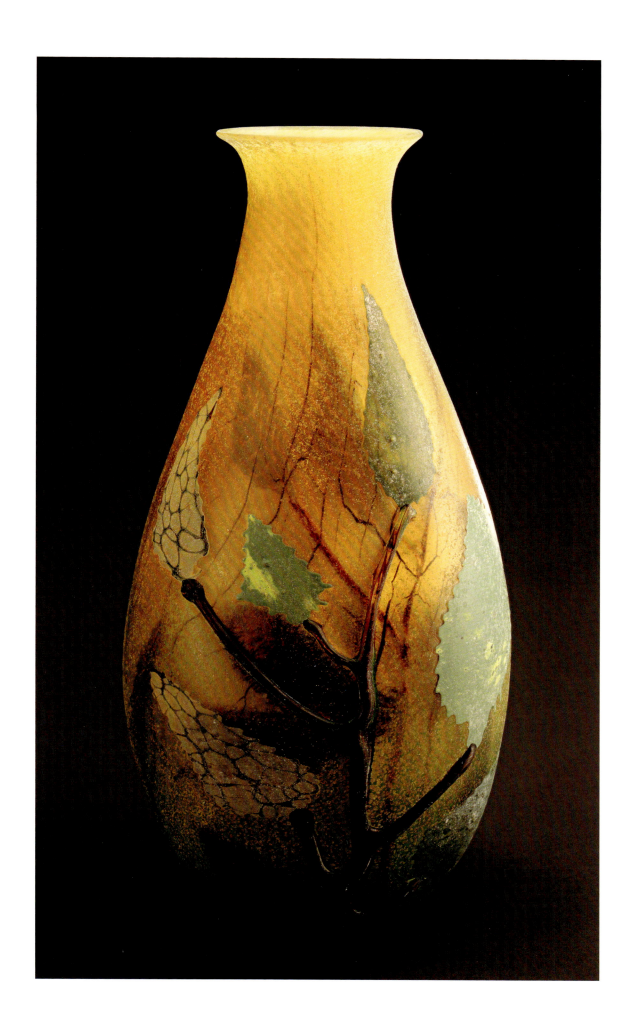

NATIVE SPECIES: VASE WITH LEAF FORMS

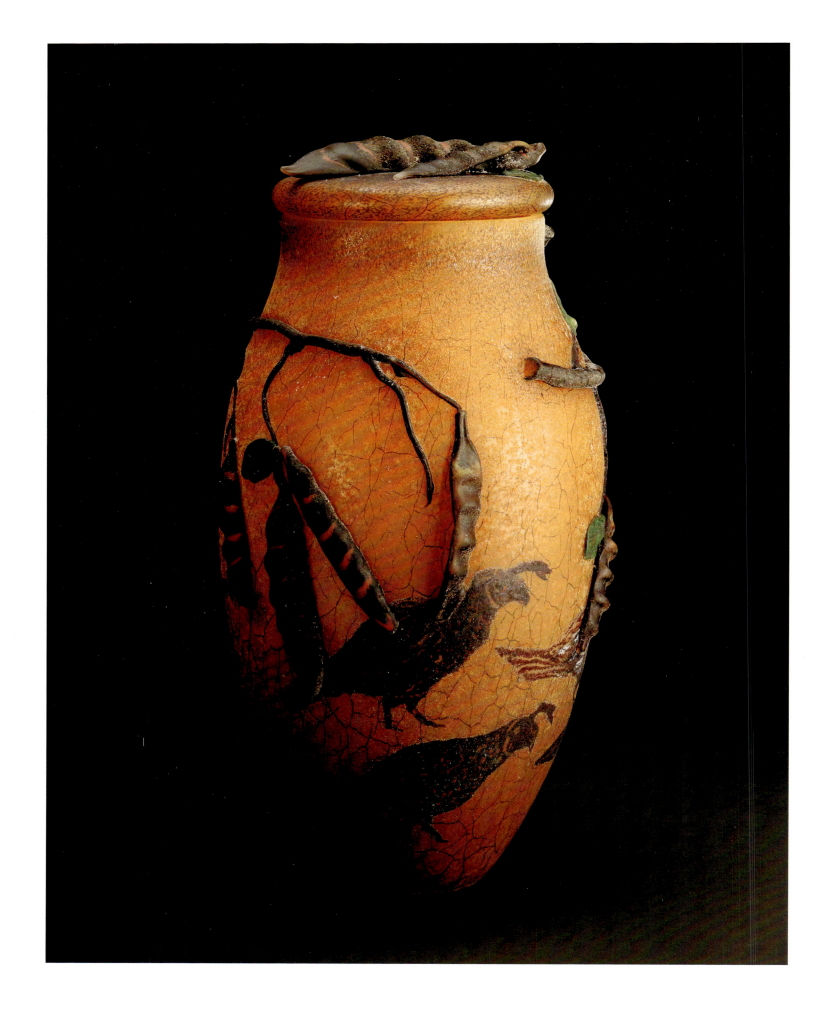

NATIVE SPECIES: VESSEL WITH CALIFORNIA QUAIL, BOUGHS, AND SEEDPODS

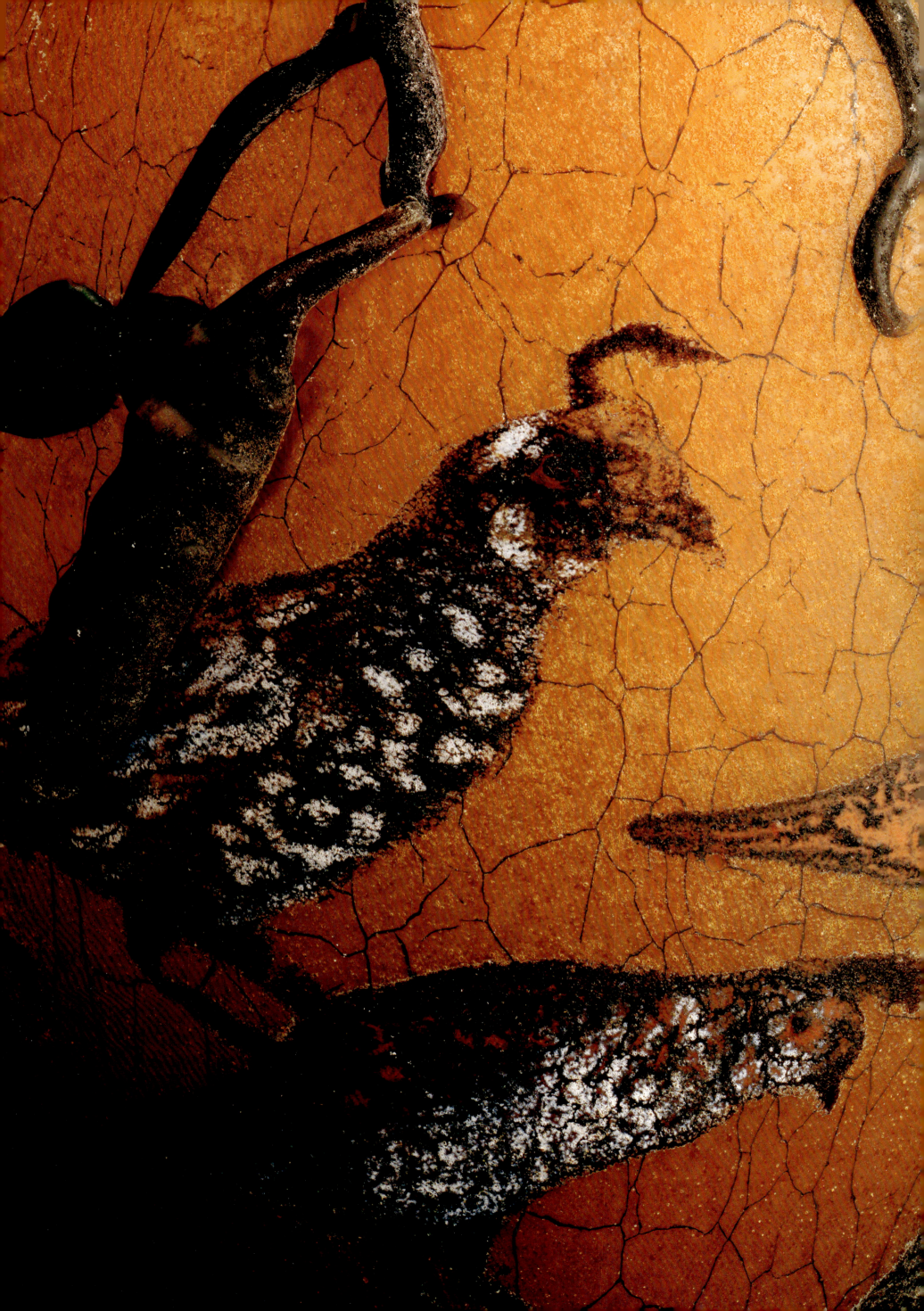

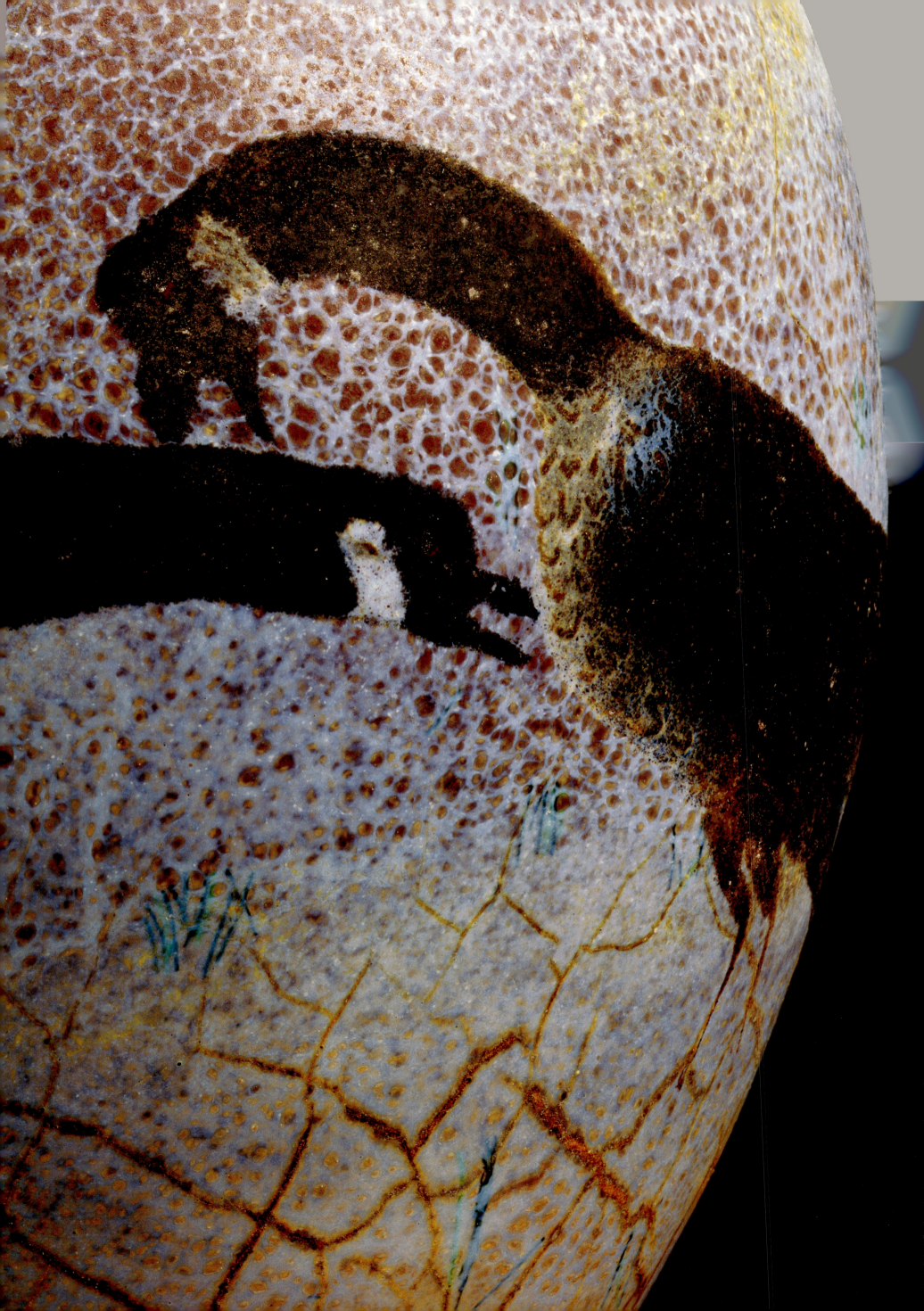

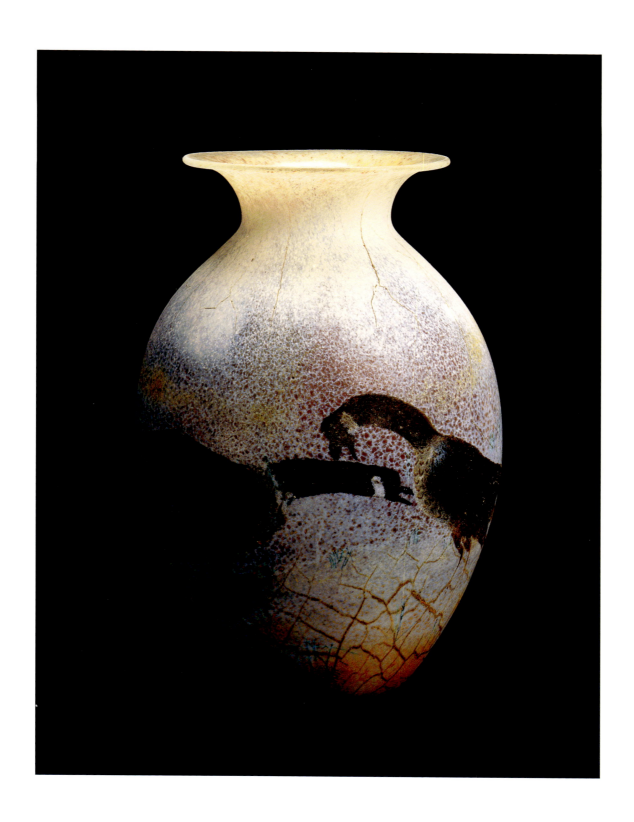

NATIVE SPECIES: VESSEL WITH GREATER CANADA GEESE

82

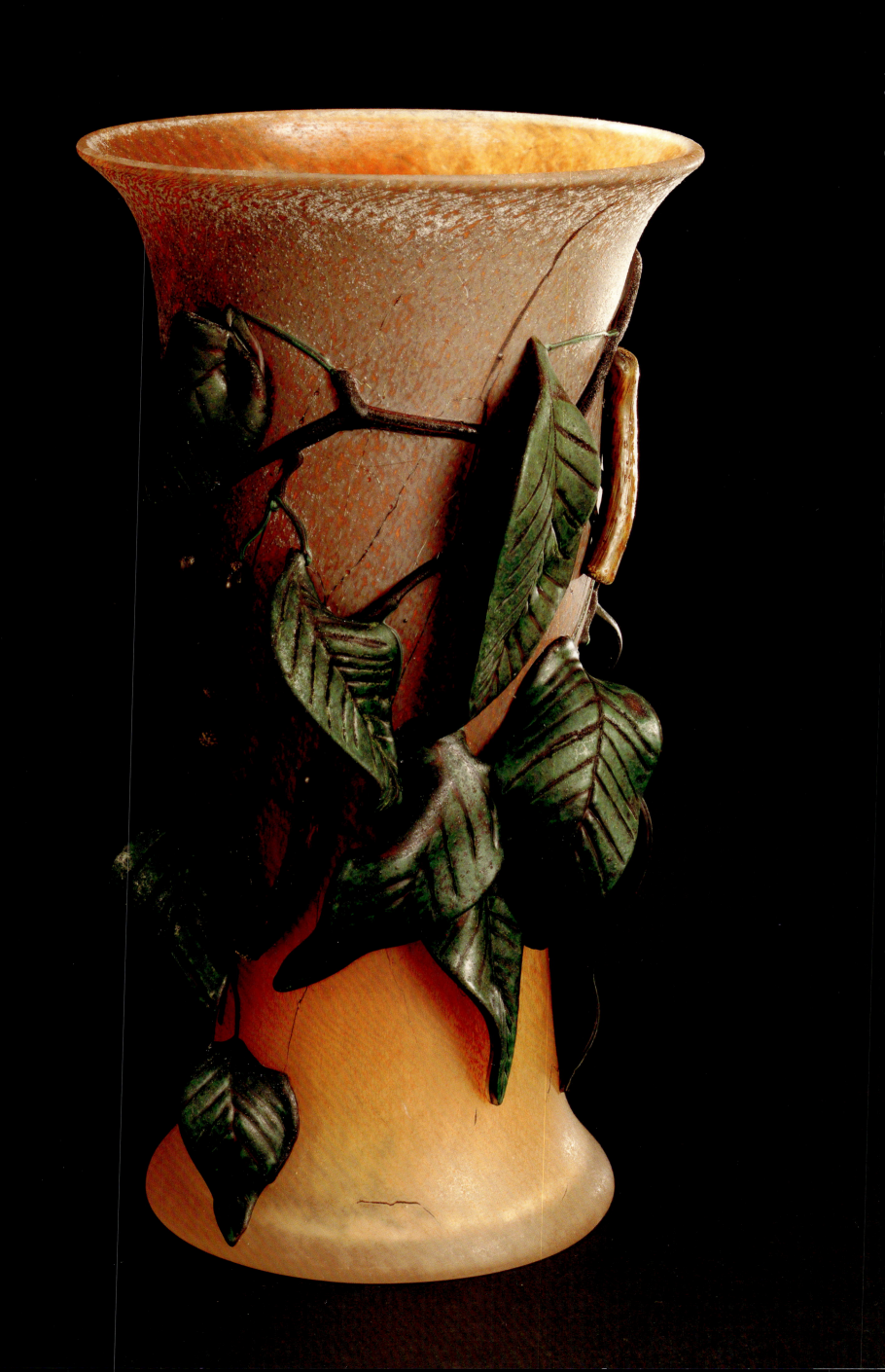

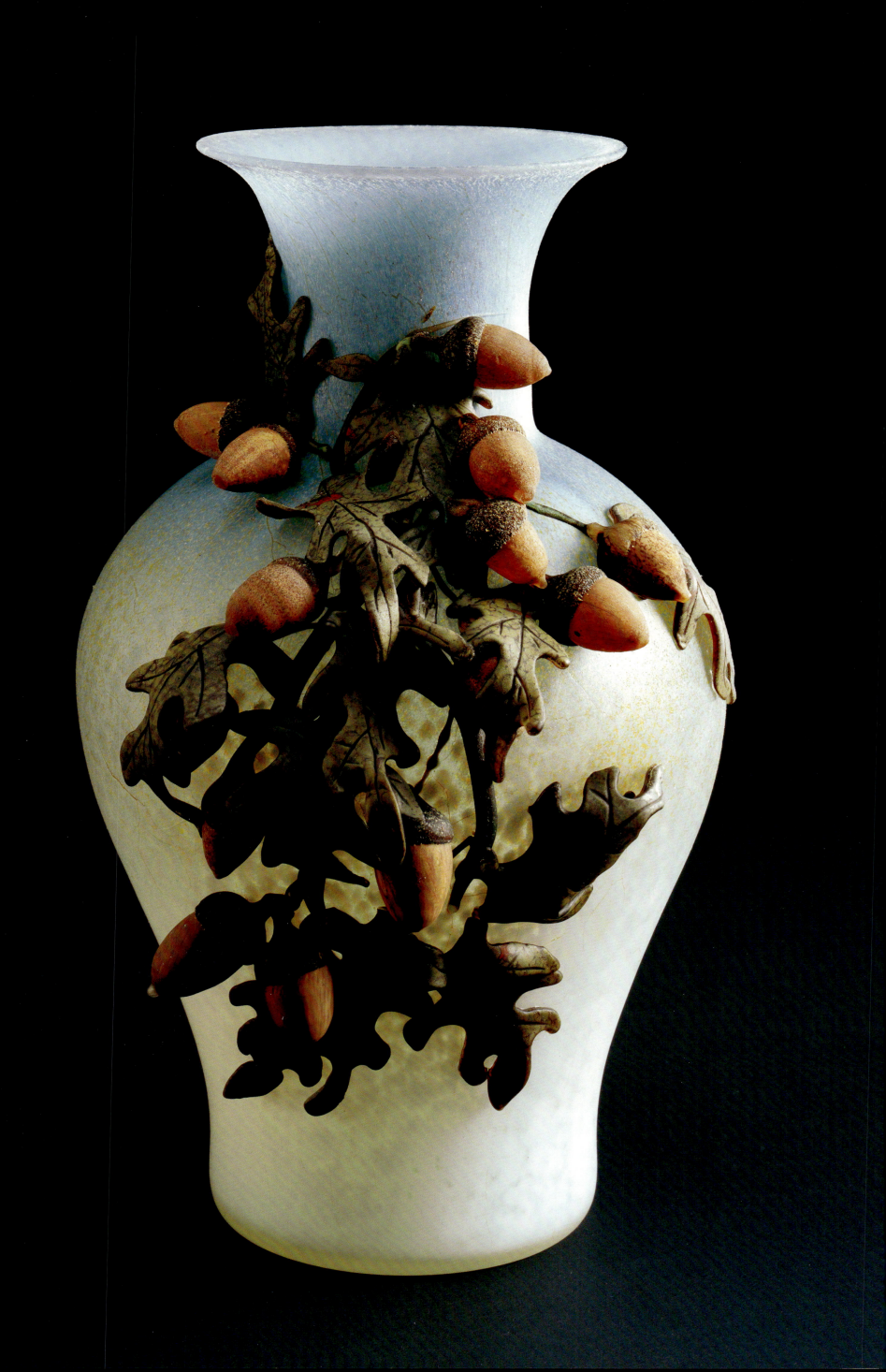

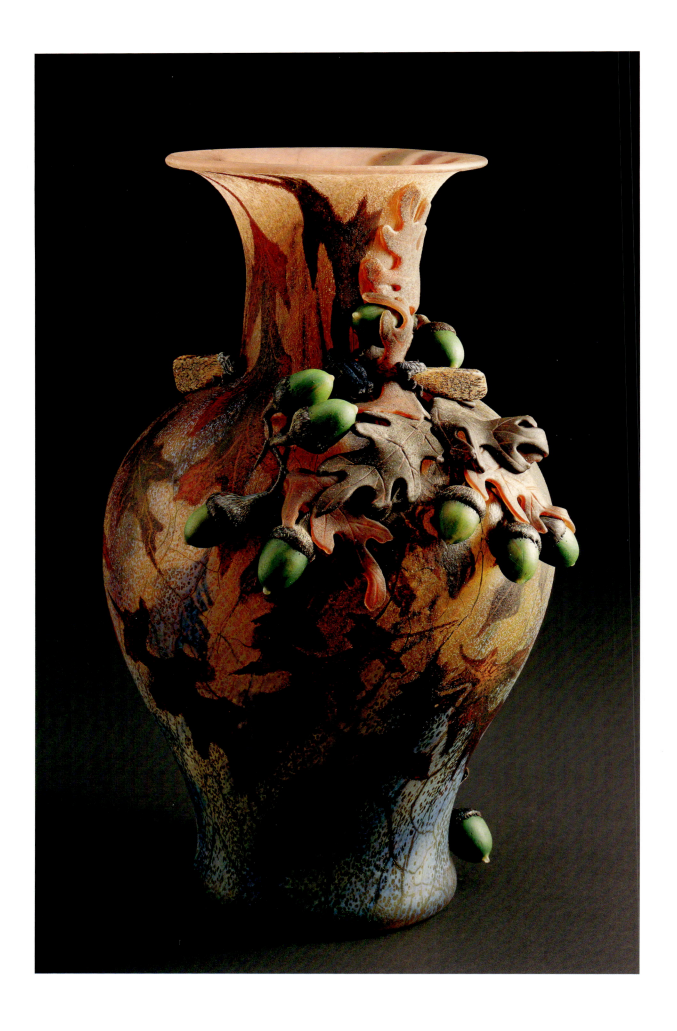

NATIVE SPECIES: VASE WITH OAK LEAVES, ACORNS, AND MOTHS

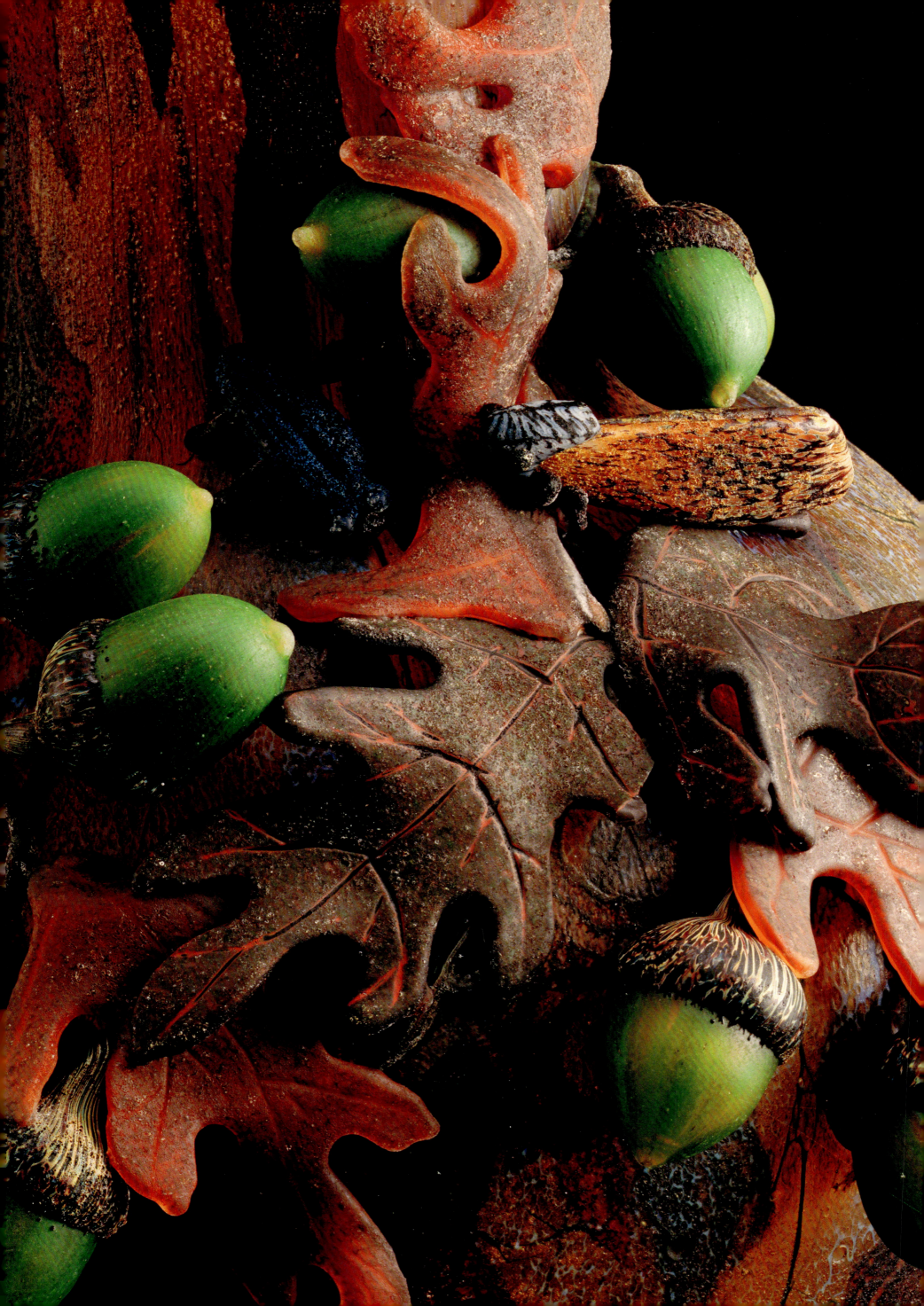

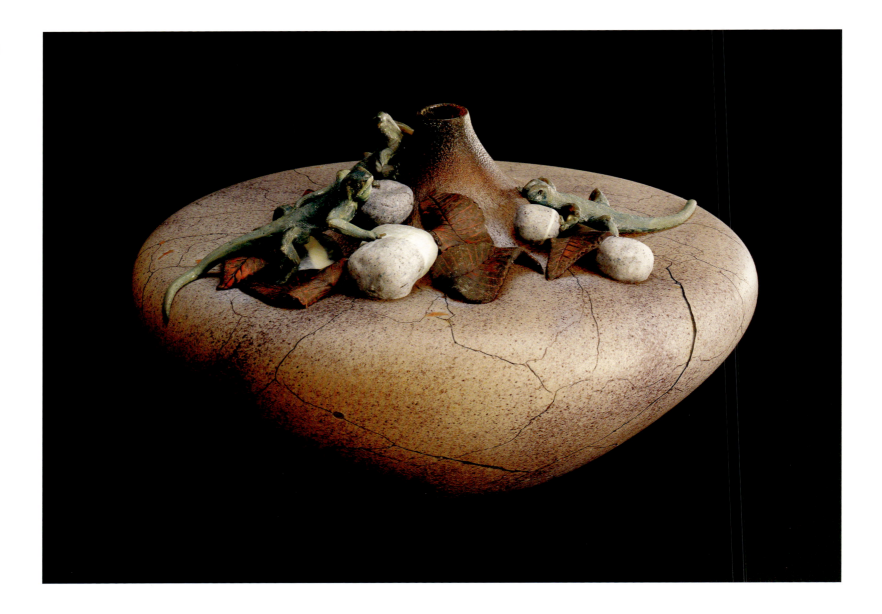

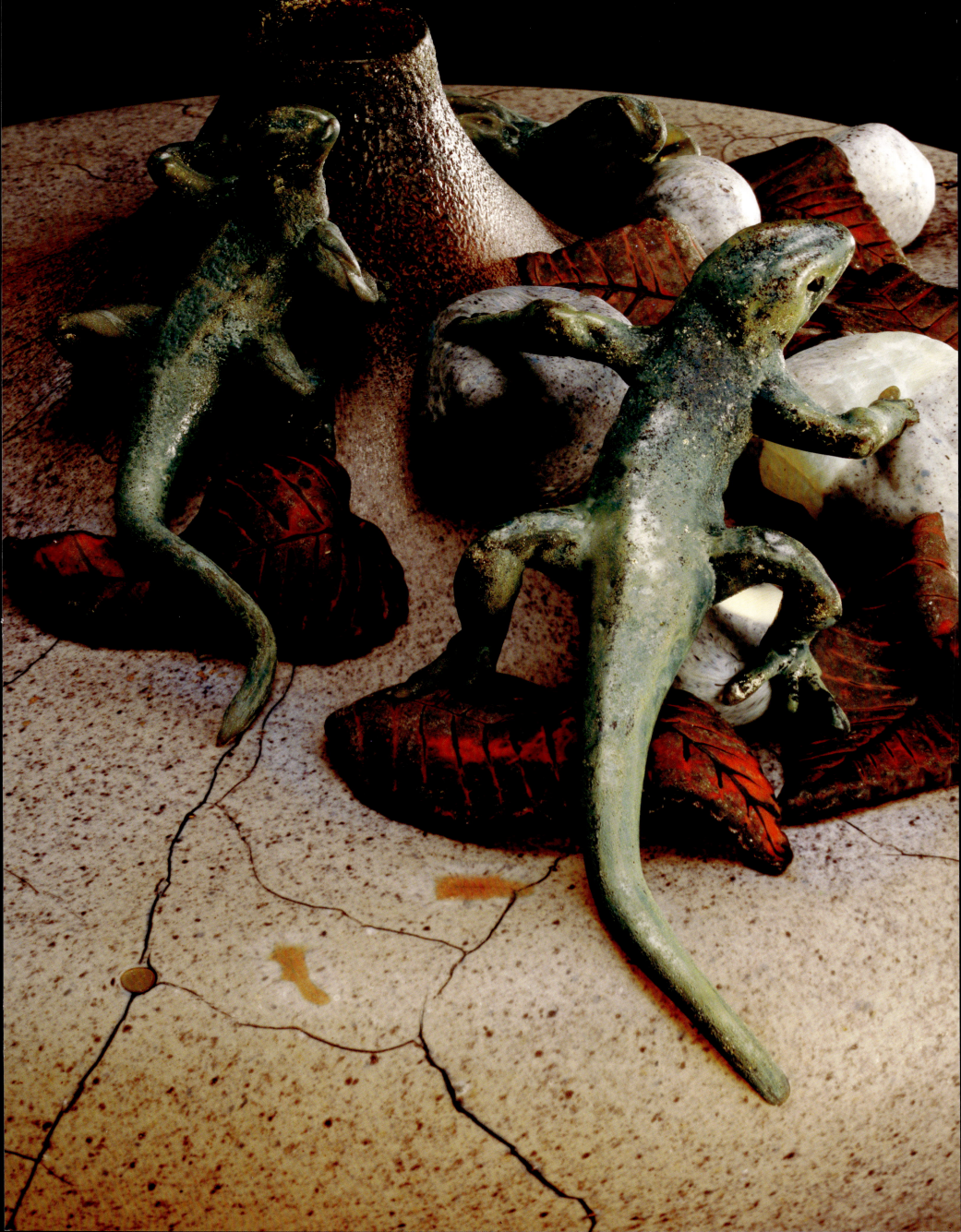

92

NATIVE SPECIES: VESSEL WITH CALIFORNIA QUAIL AND LOCUST PODS [DETAIL OVERLEAF]

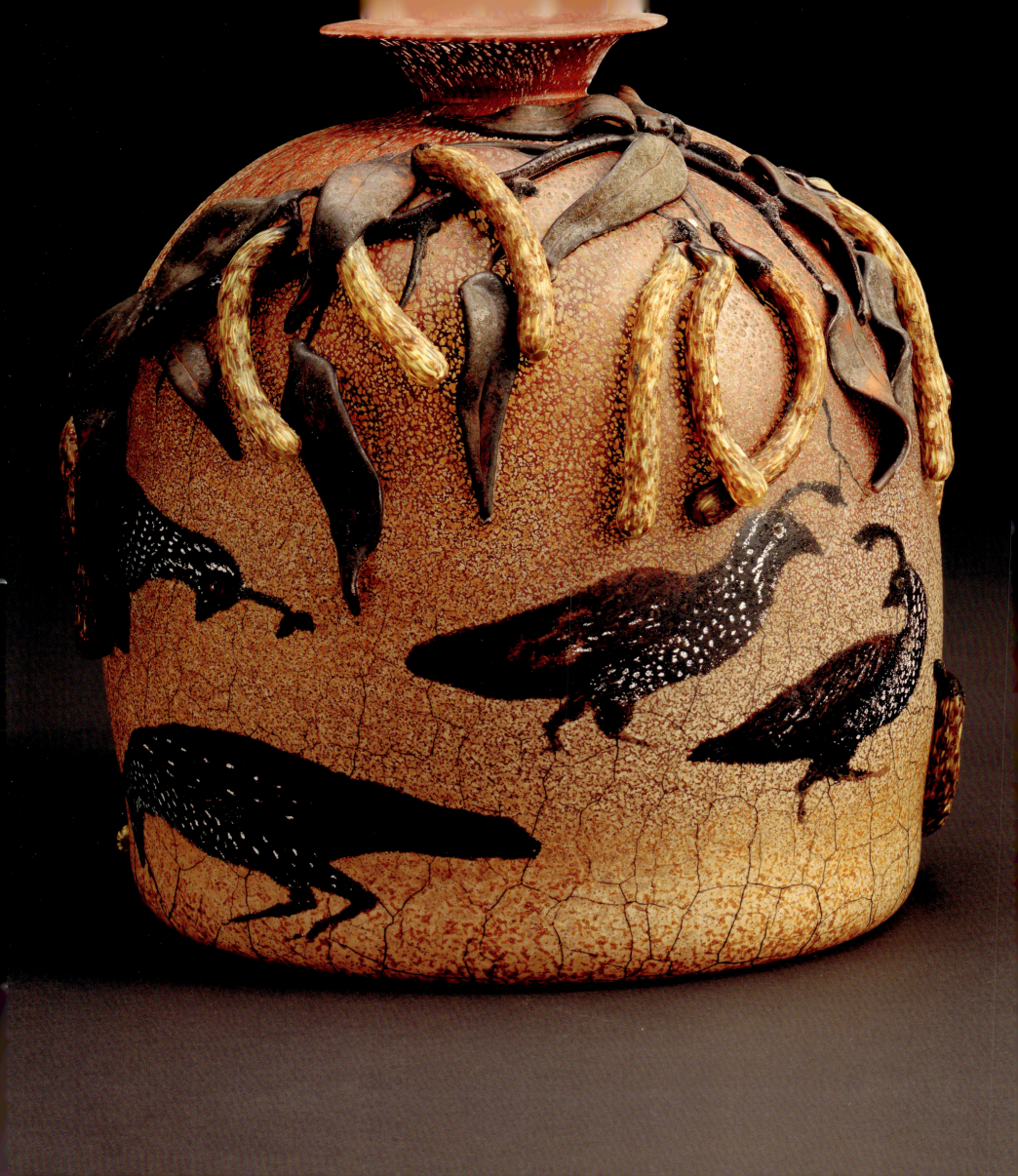

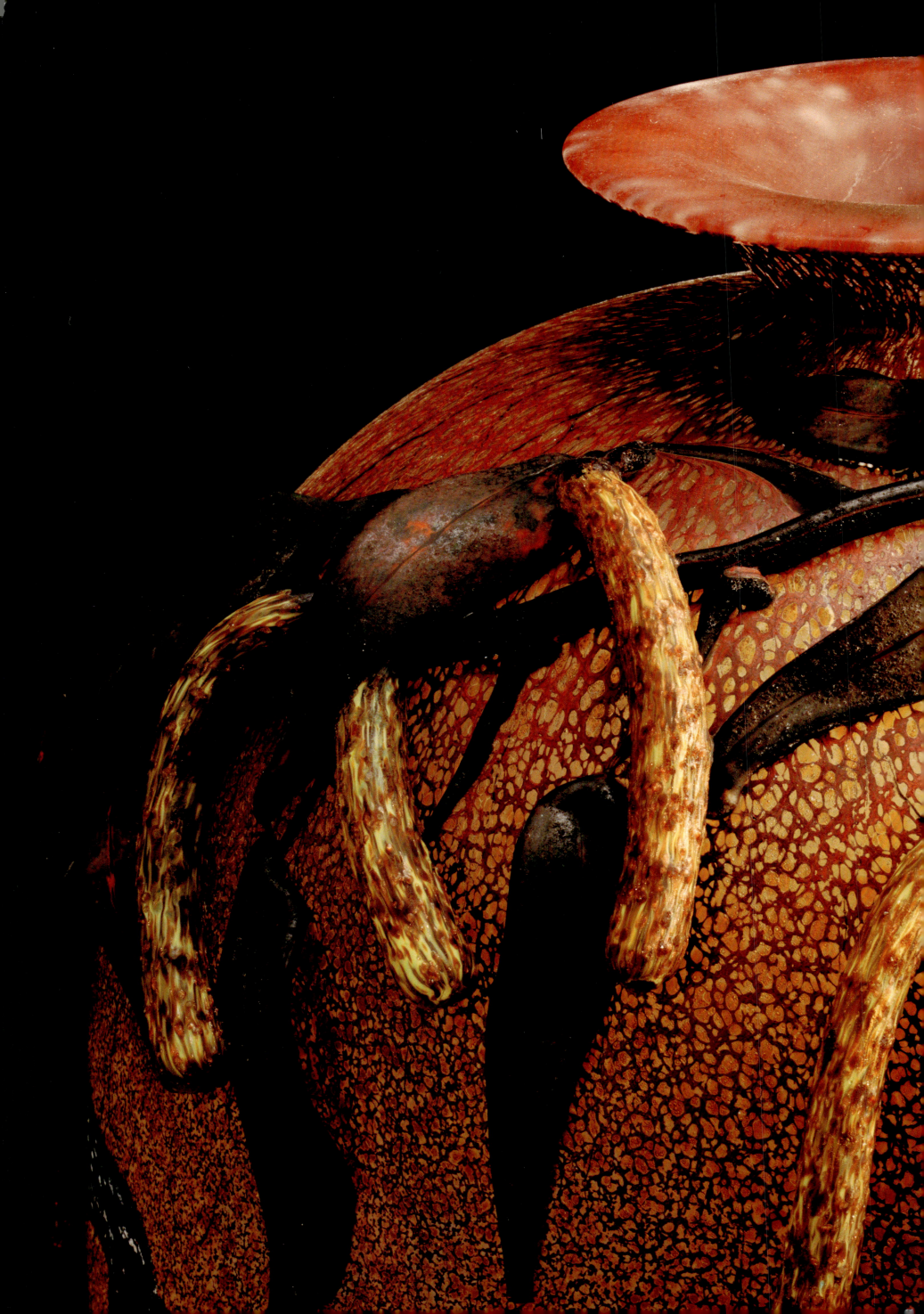

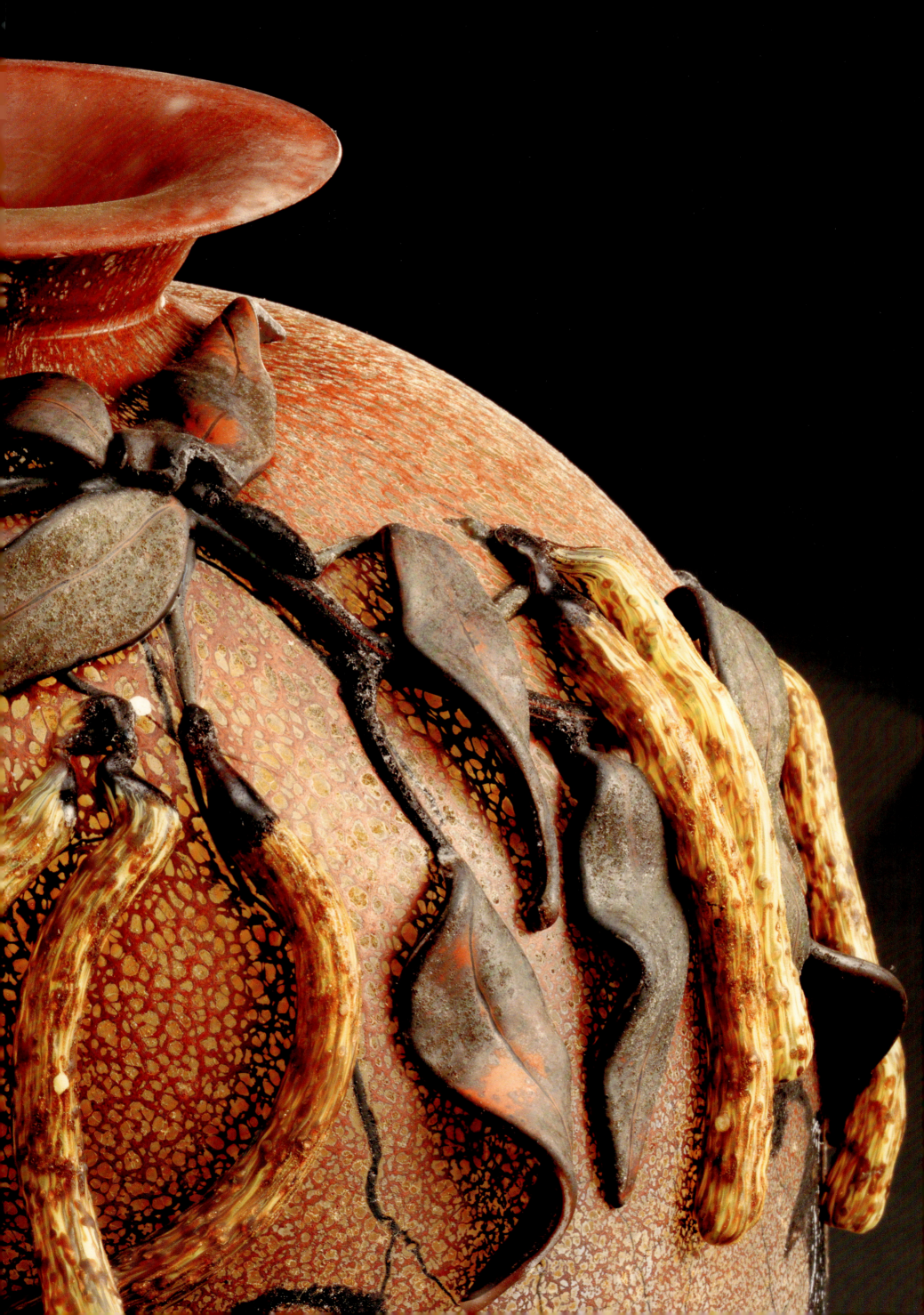

96

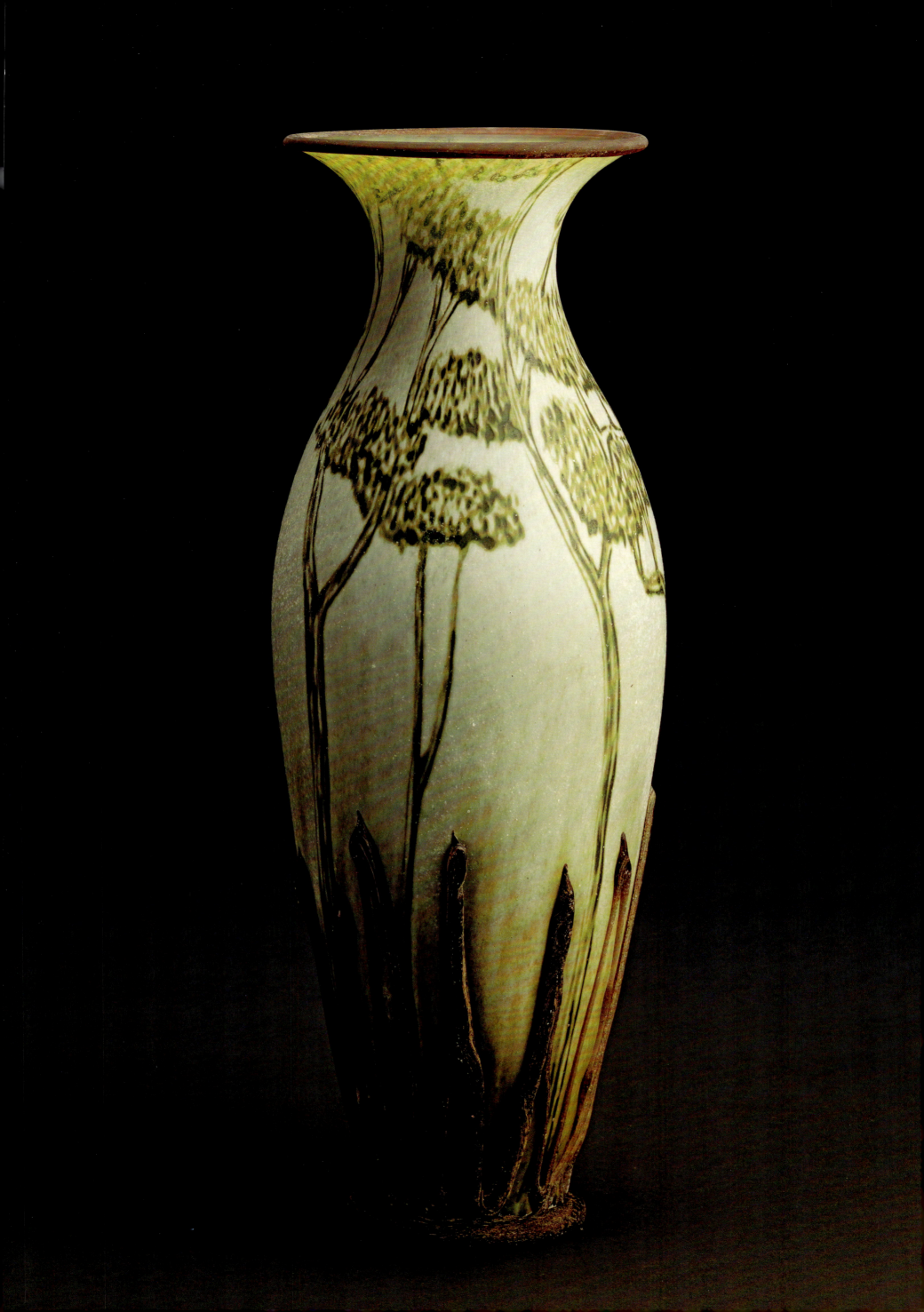

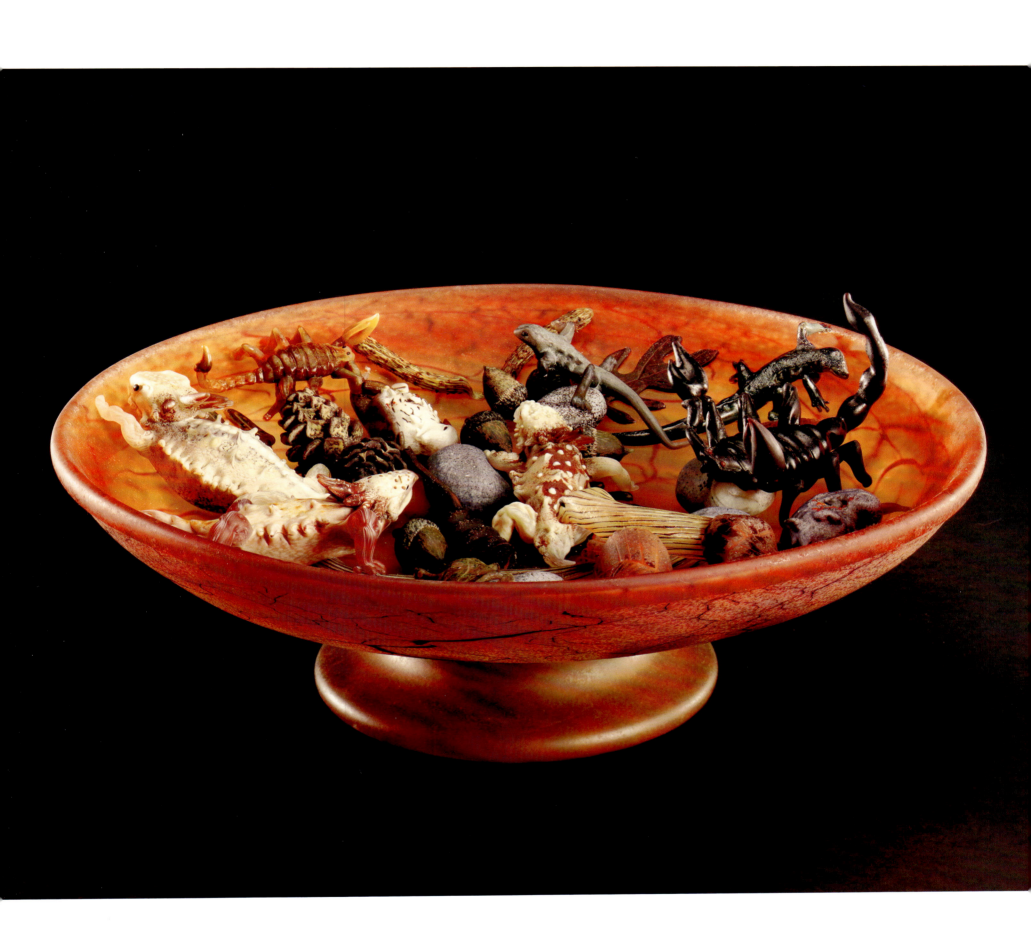

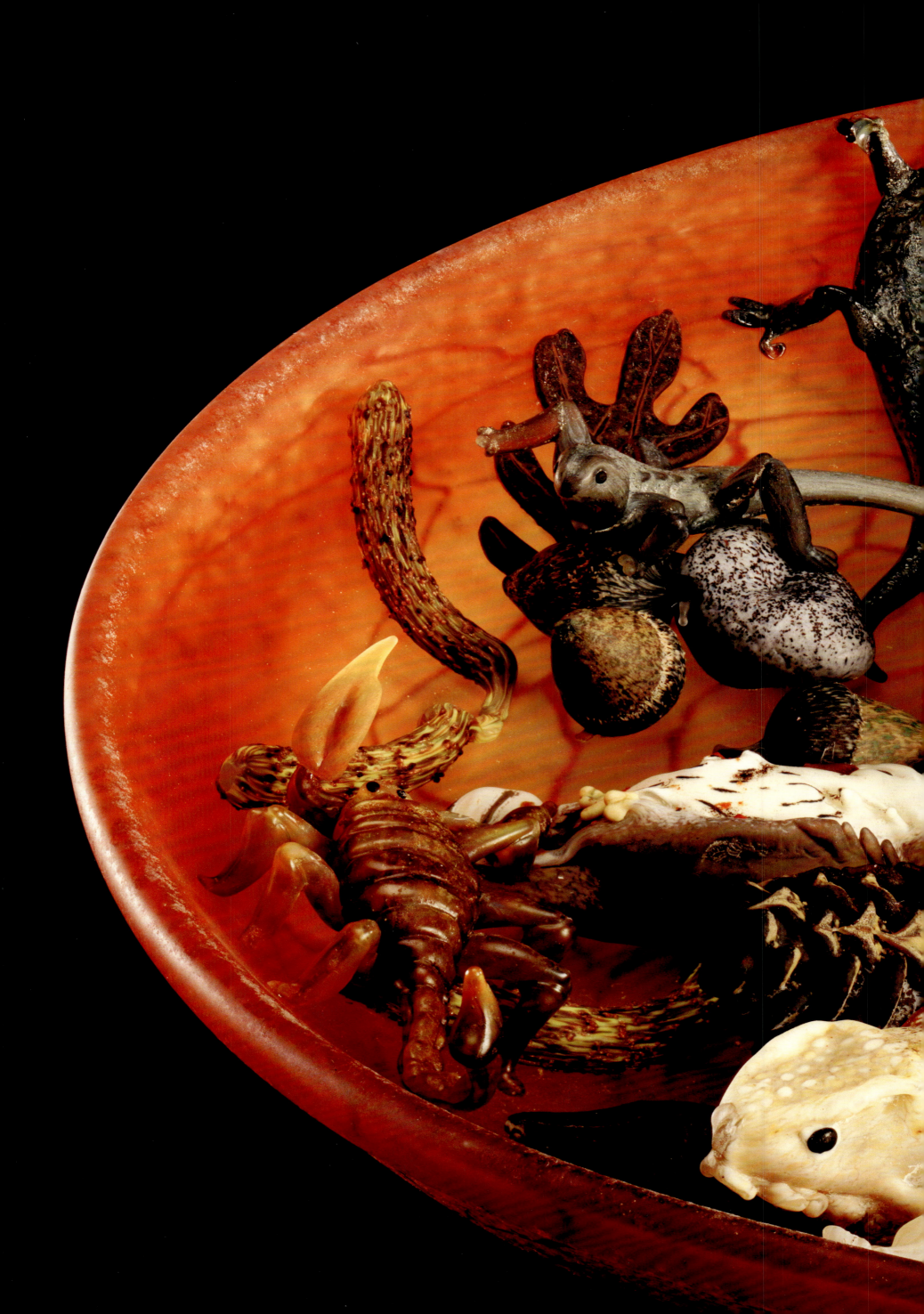

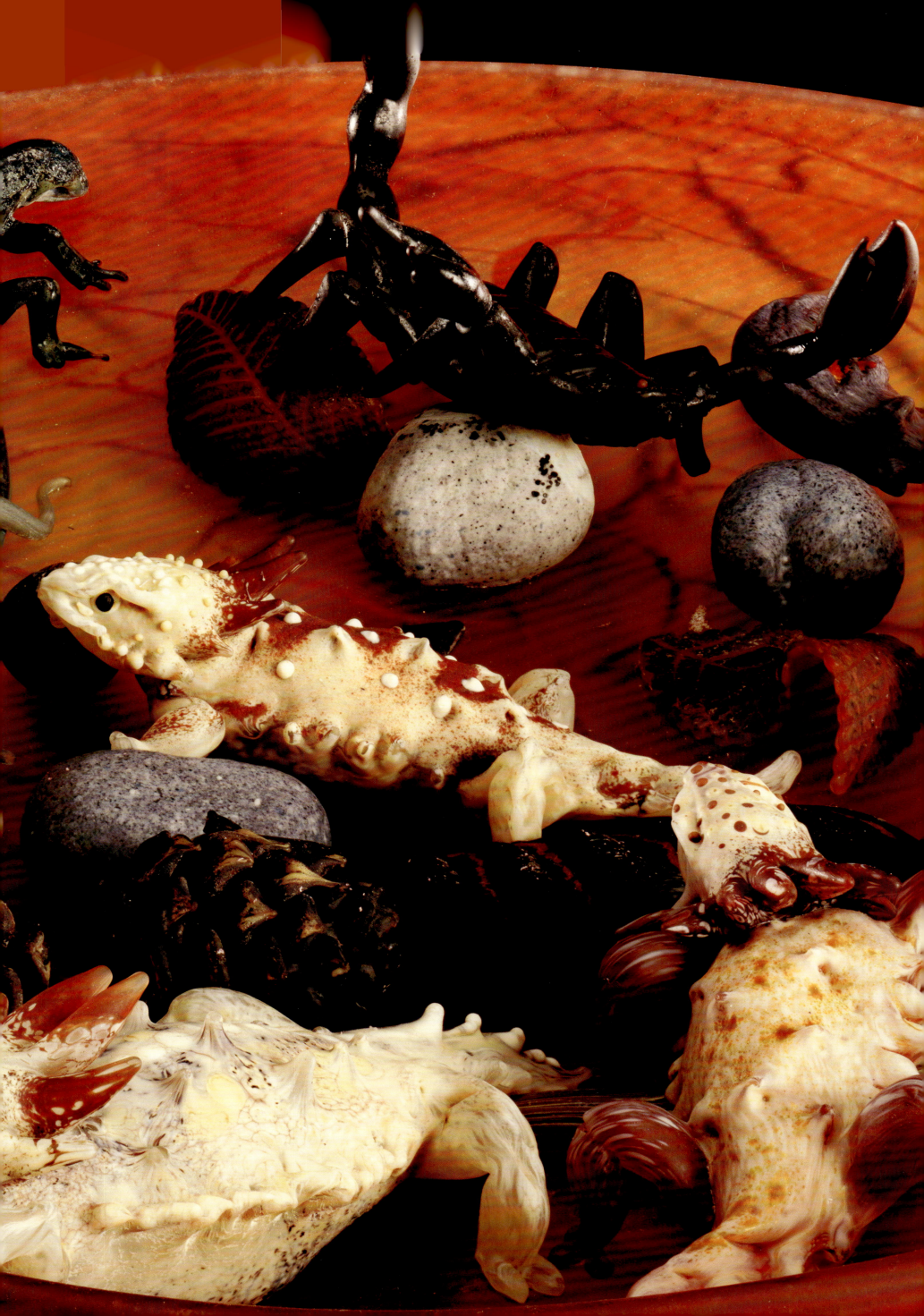

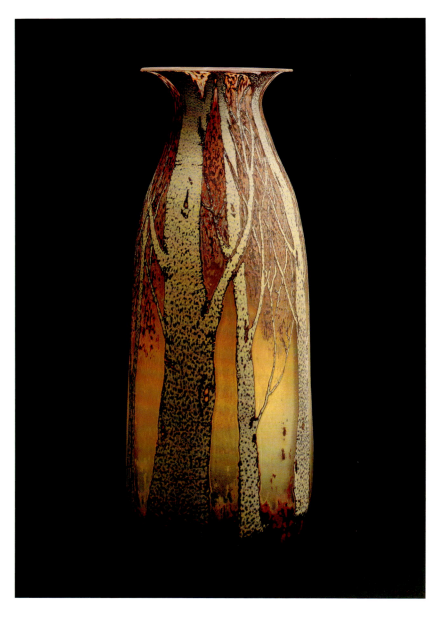

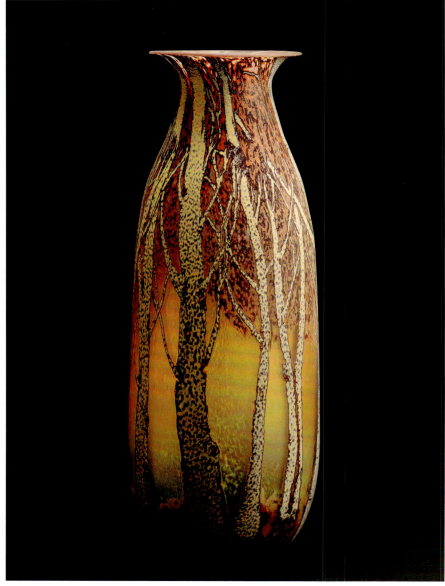

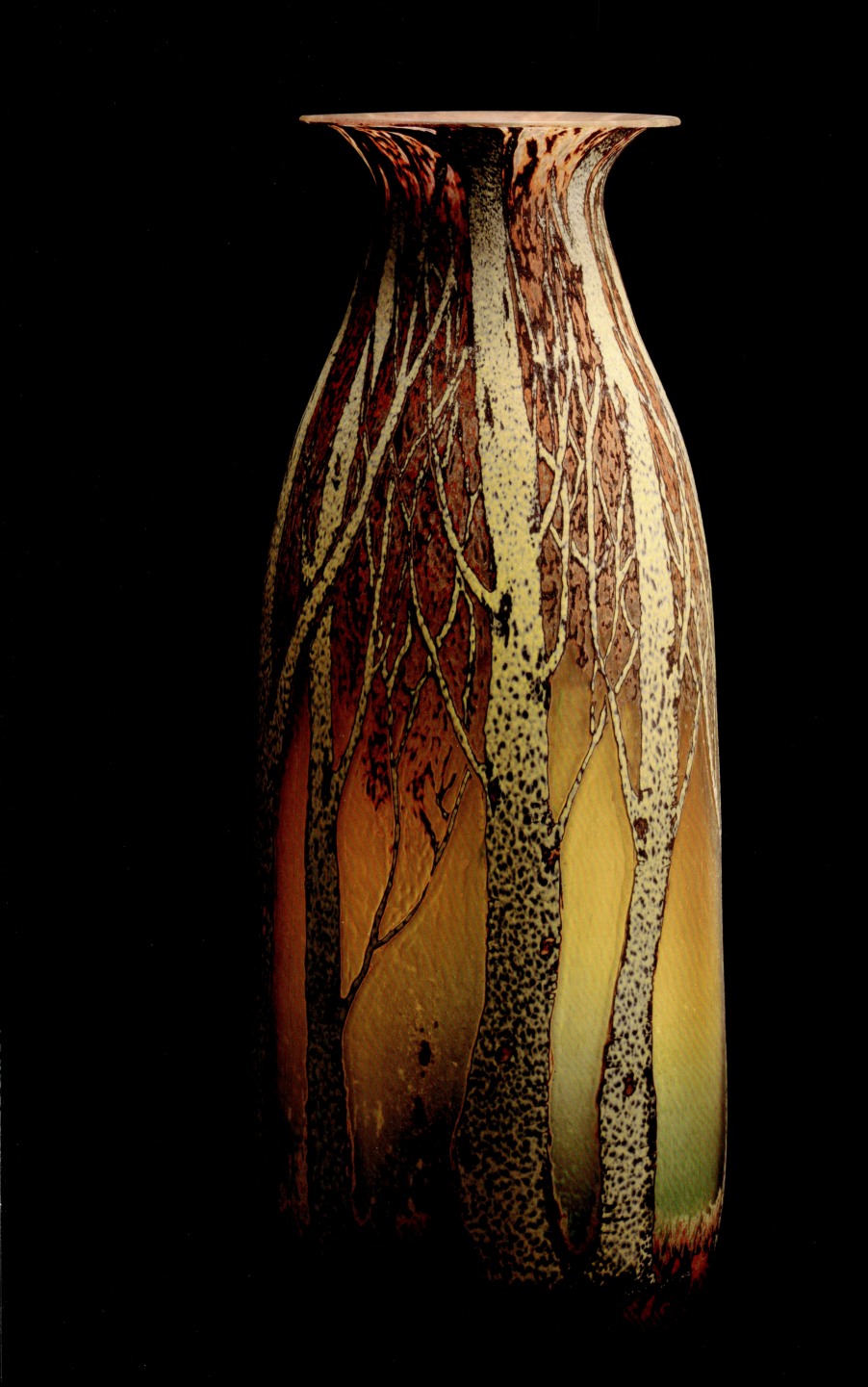

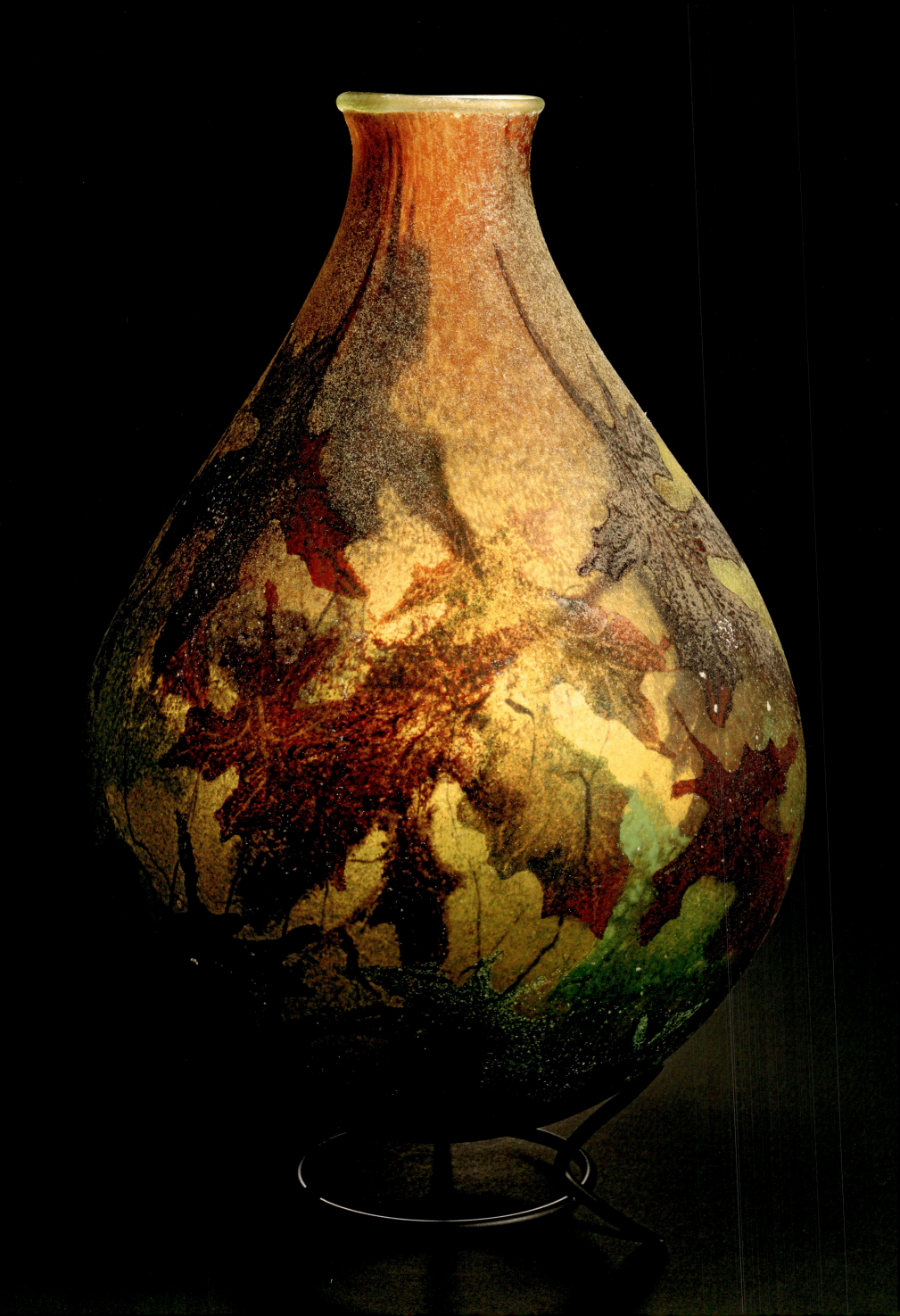

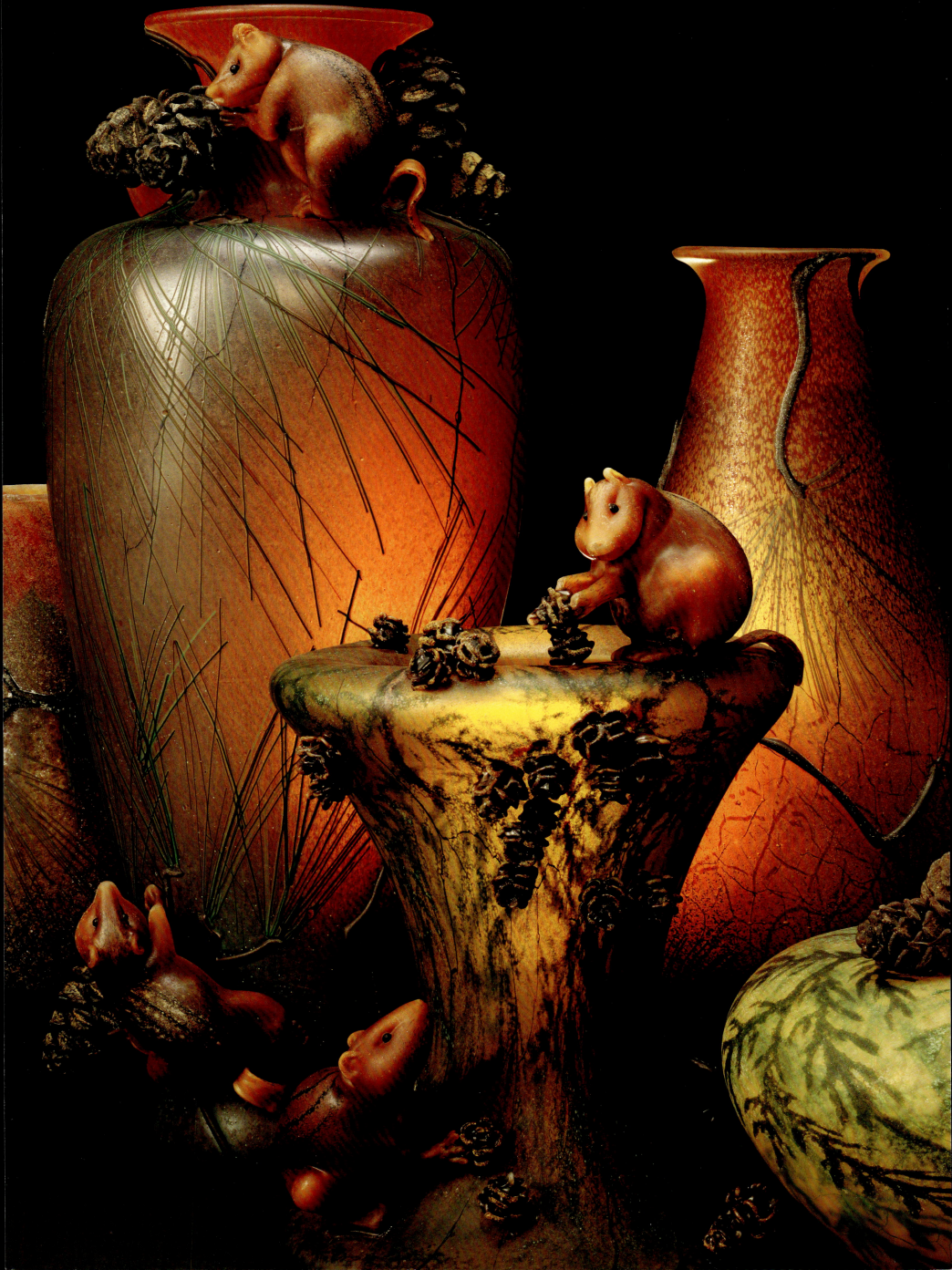

112

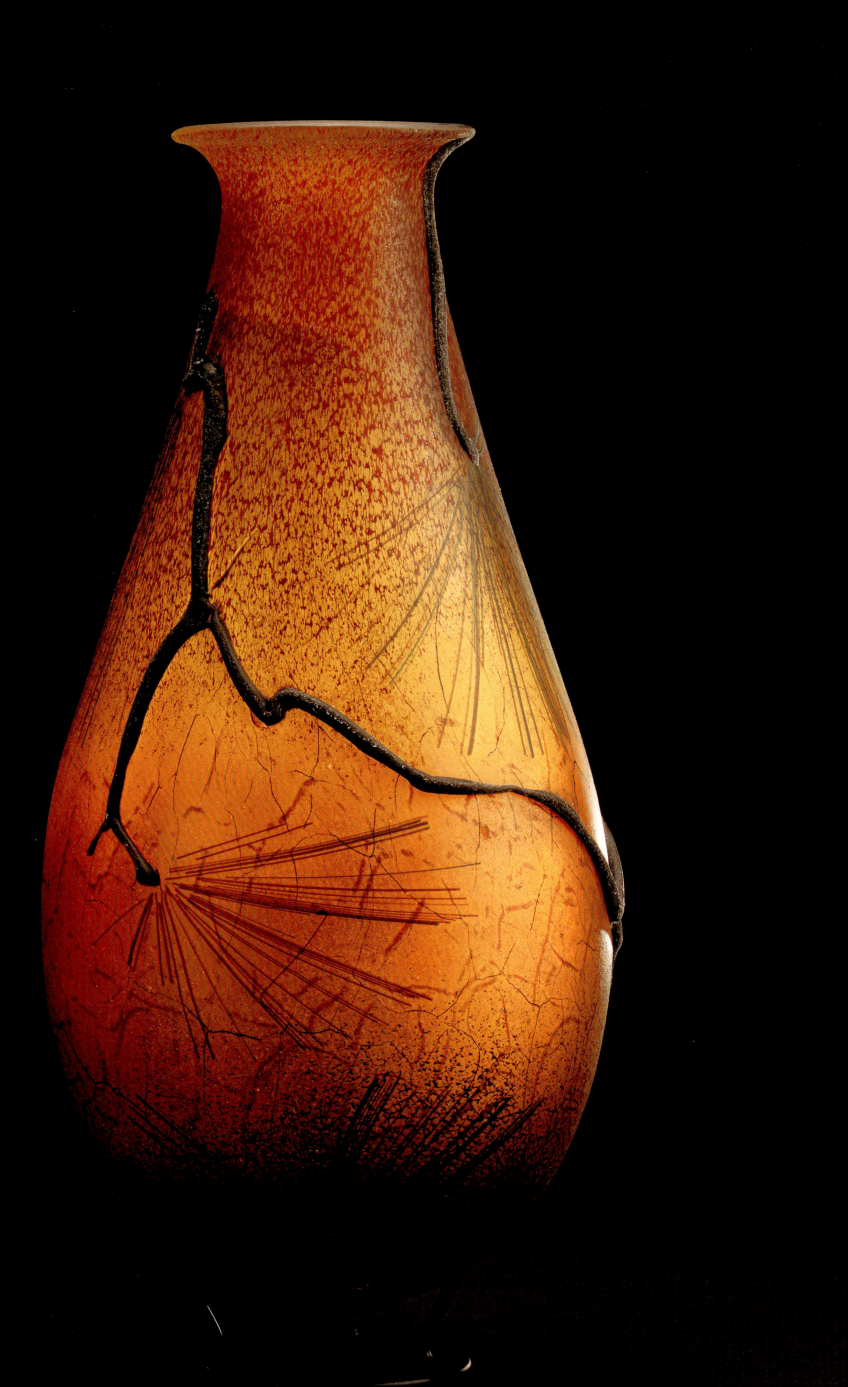

114

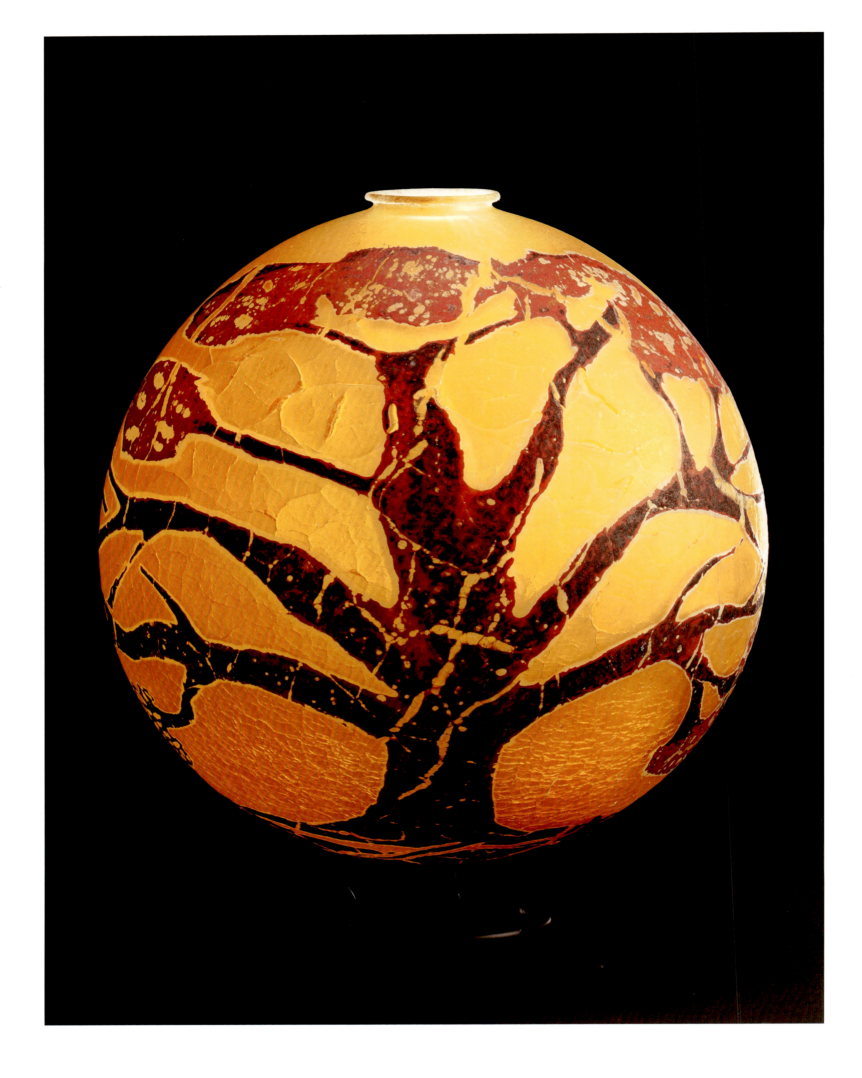

3 NATIVE SPECIES: GLOBE VESSEL WITH JUNIPER TREE FORM

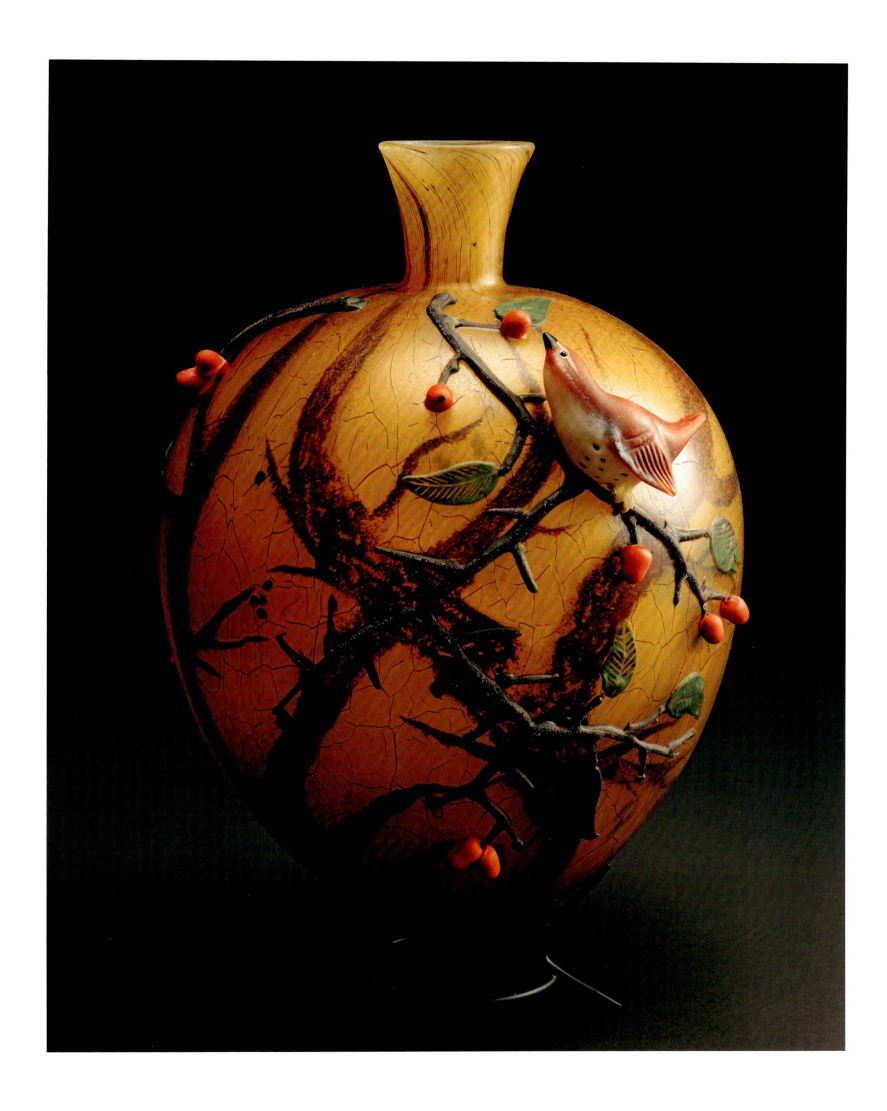

NATIVE SPECIES: VASE WITH WREN AND BERRIES

Objects in the Collection

All objects are blown glass,
from the *Native Species* series,
2004, George R. Stroemple
Collection. All dimensions are
in inches; height precedes
width precedes depth.

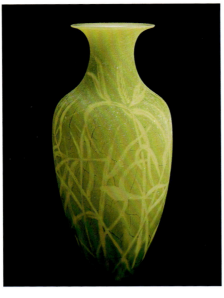

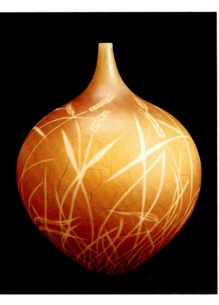

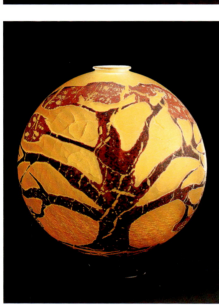

4 *Globe Vessel with Leaves*
Multilayered dusted graal, engraved
leaves; 8¼ × 9¾ × 9¾ (p. 53)

5 *Stamnos with Engraved Vine*
Amber- and red-dusted, engraved vine;
9⅝ × 7⅜ × 7¼ (p. 52)

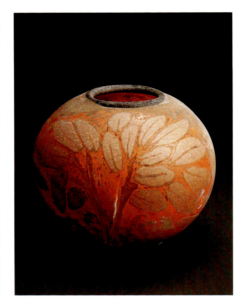

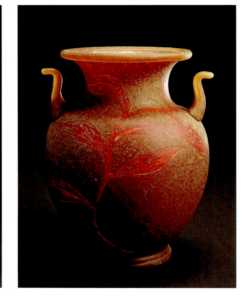

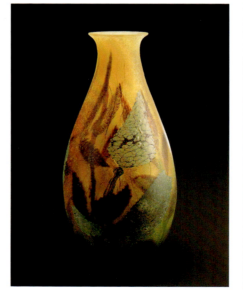

7 *Vase with Trees and Pods*
White to green dusted graal, engraved
trees, applied pods; 18¼ × 6⅜ × 6⅜
(p. 97)

8 *Vase with Deer*
Dust-drawn deer; 21⅝ × 6¼ × 6¼
(pp. 54–55)

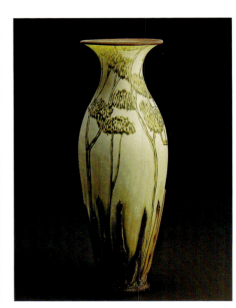

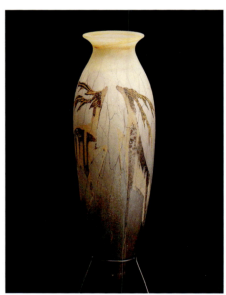

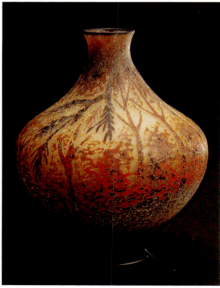

1 *Vase with Wild Grass (Green)*
Green over white graal, engraved
wild grass; 18⅝ × 8½ × 8½ (p. 69)

2 *Vessel with Wild Grass (Amber)*
Amber over white graal, engraved
wild grass; 20½ × 15¾ × 15¾ (p. 68)

3 *Globe Vessel with Juniper
Tree Form*
Dusted golden graal, engraved tree
and crackled; 11⅛ × 9¾ × 9¾ (p. 114)

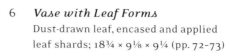

6 *Vase with Leaf Forms*
Dust-drawn leaf, encased and applied
leaf shards; 18¾ × 9⅛ × 9¼ (pp. 72–73)

9 *Vessel with Cedar Boughs*
Multilayered dusted graal, engraved
cedar bough; 10½ × 8 × 8 (p. 61)

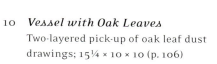

10 *Vessel with Oak Leaves*
 Two-layered pick-up of oak leaf dust
 drawings; 15¼ × 10 × 10 (p. 106)

11 *Vessel with Cedar Boughs and
 Cedar Cones*
 Two-layered pick-up of dust-drawn
 cedar bough, applied cedar cones;
 7⅞ × 9⅛ × 9⅛ (pp. 43–45)

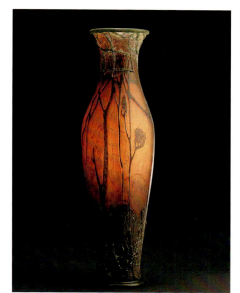

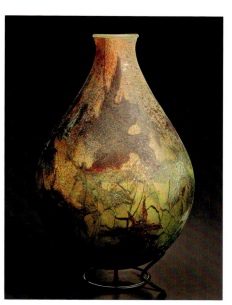

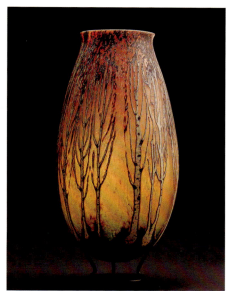

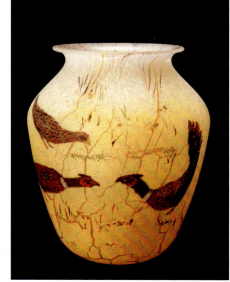

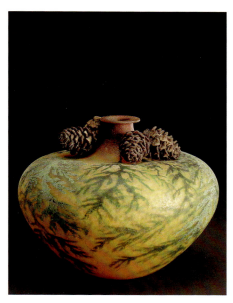

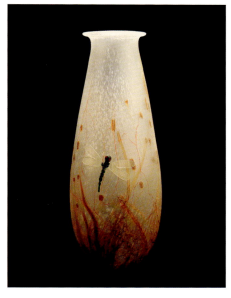

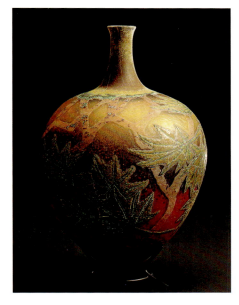

13 *Vase with Aspen Grove*
 Multilayered dusted graal, engraved
 aspen tree grove; 26½ × 10 × 10
 (pp. 104–105)

14 *Vase with Poplar Grove*
 Multilayered dusted graal, engraved
 poplar tree grove; 15 × 7⅛ × 7⅛ (p. 39)

15 *Vase with Dragonfly and Grasses*
 Shaded dusting, glass cane grasses,
 applied sculpted dragonfly with
 dichroic wings; 21¼ × 7¾ × 7¾
 (pp. 70–71)

16 *Vase with Grass and Trees*
 Engraved tree branches, hot-glass
 applied grass and trees; 16 × 11 × 10⅜
 (p. 76)

17 *Vessel with Ring-Necked
 Pheasants*
 Dust-drawn pheasants; 12¾ × 9½ × 9½
 (pp. 65–67)

12 *Vessel with Vine Maple Leaves*
 Engraved multilayered dusted
 graal with vine maple leaves;
 14½ × 9⅝ × 9⅝ (pp. 62–63)

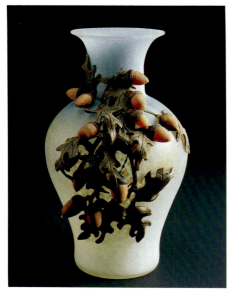

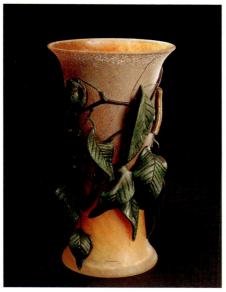

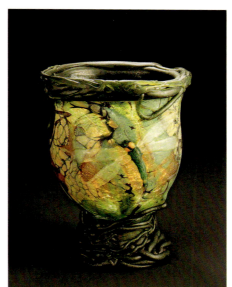

29 *Elongated Vase with Ponderosa Pine Needles and Single Cone*
Dust-drawn pine boughs, pick-up of pine needles, hot-glass applied boughs and pine cone; 13½ × 7 × 7 (pp. 84–85)

30 *Vase with Wren and Berries*
Dust-drawn berry bush, applied boughs, engraved leaves, berries, and bird; 10 × 8⅜ × 7½ (p. 115)

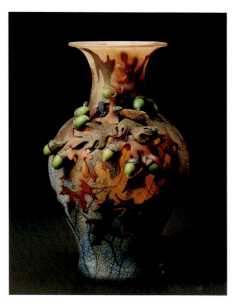

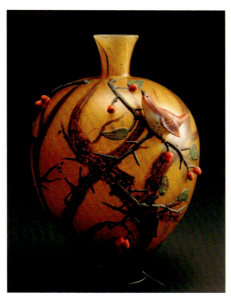

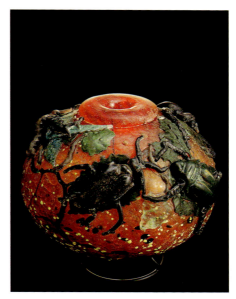

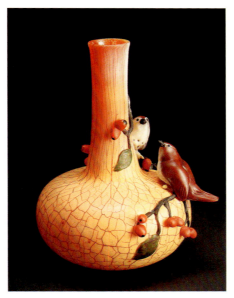

26 *Ice Blue Vase with Oak Leaves and Acorns*
Dusted vessel, applied oak boughs, engraved leaves and acorns; 13½ × 8¾ × 7¾ (p. 87)

27 *Vase with Leaves and Locust Pods*
Dusted vessel, applied boughs, engraved leaves and locust pods; 11⅜ × 6¼ × 6¼ (p. 83)

28 *Vase with Oak Leaves, Acorns, and Moths*
Multilayered pick-up of oak leaves, hot-glass applied engraved oak leaves, acorns, and moths; 15¹¹⁄₁₆ × 9¼ × 8¾ (pp. 88–89)

31 *Long-Necked Vase with Wrens and Berries*
Dusted vessel, applied berry bush and birds; 10¼ × 8½ × 7½ (pp. 56–57)

32 *Footed Dragonfly Bowl*
Dusted vessel, hot-glass applied shards, wrapping on lip and foot, and hot-glass applied sculpted dragonfly; 9¾ × 7⅝ × 8 (p. 74)

33 *Globe Vessel with Beetles and Centipedes*
Crackled vessel, jimmies and shard pick-ups, hot-glass applied beetles and centipedes; 7½ × 7¾ × 7⅝ (pp. 98–99)

34 *Desert Vessel with Lizards,*
 Rocks, and Leaves
 Dusted vessel, hot-glass applied rocks,
 engraved leaves, and sculpted lizards;
 8 × 13¼ × 13½ (pp. 90-91)

35 *Footed Specimen Bowl*
 Hot-glass applied desert artifacts;
 6⅞ × 16½ × 16½ (pp. 101-103)

36 *Vase with Cedar Boughs and*
 Golden-Mantled Ground Squirrels
 Double pick-up of dust-drawn cedar
 boughs, applied cedar cones and
 ground squirrels; 14¾ × 10¼ × 9⅝
 (p. 58)

124

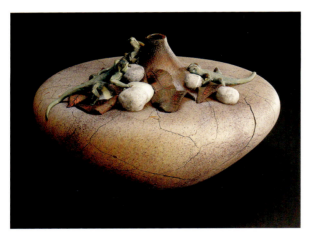

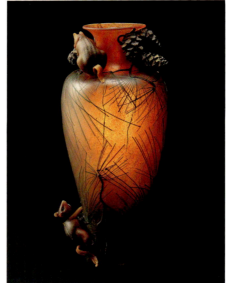

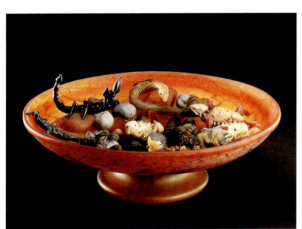

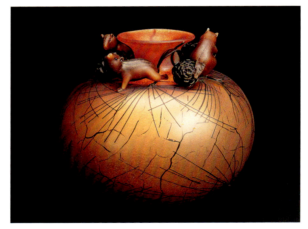

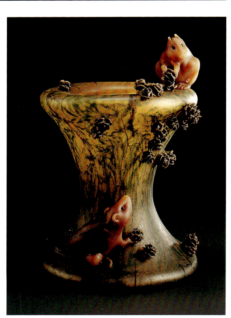

37 *Vase with Ponderosa Pine*
 Needles and Golden-Mantled
 Ground Squirrels
 Dusted vessel, pine needle pick-up,
 hot-glass applied boughs, sculpted
 pine cones and ground squirrels;
 23¾ × 10¾ × 10 (pp. 110-111)

38 *Globe Vessel with Ponderosa*
 Pine Needles and Golden-Mantled
 Ground Squirrels
 Dusted vessel, pine needle pick-up,
 hot-glass applied boughs, sculpted
 pine cones and ground squirrels;
 16 × 16 × 16 (pp. 108-109)

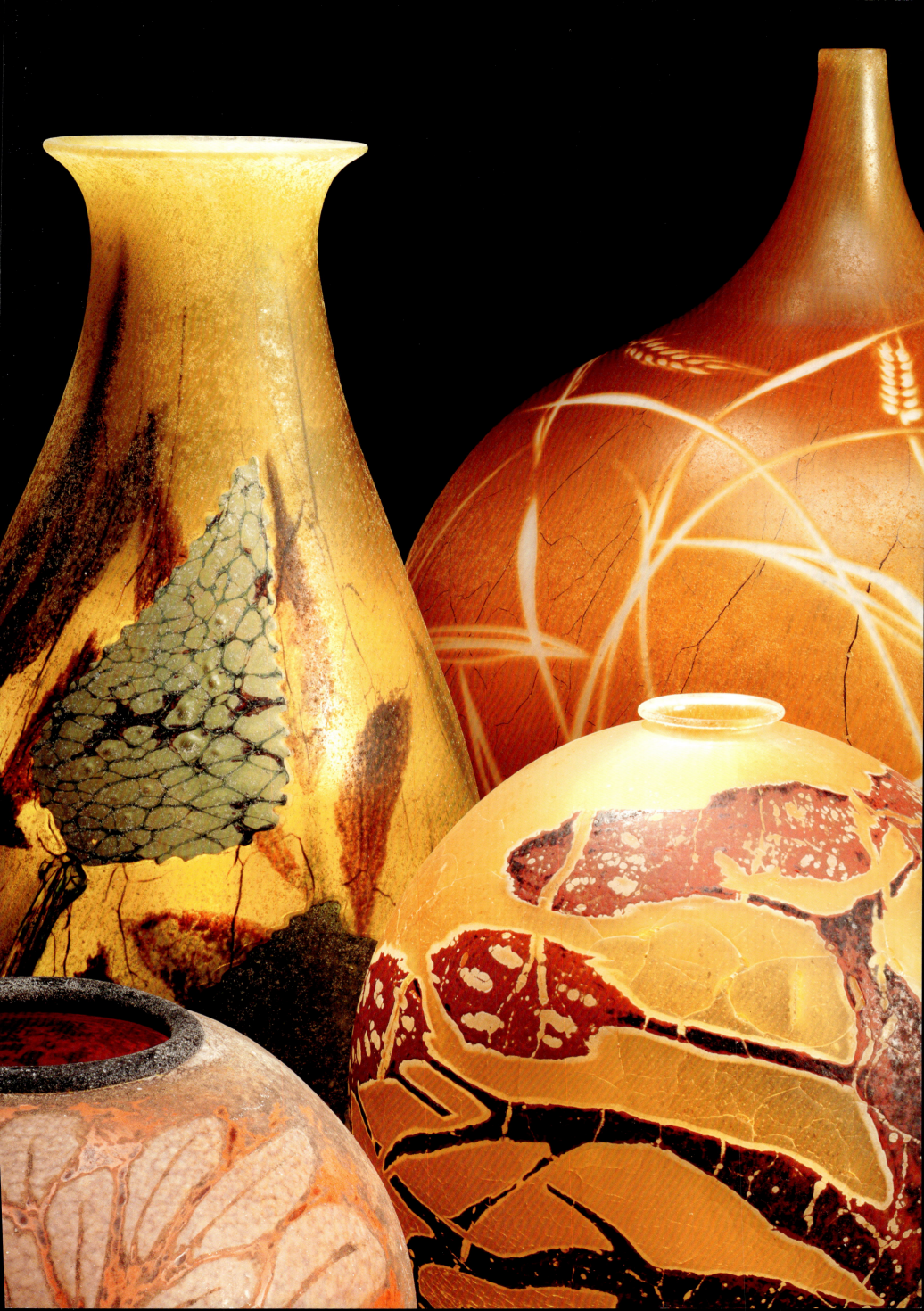

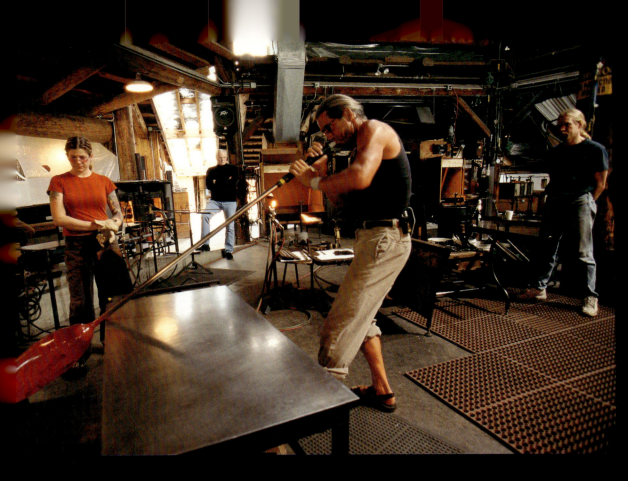
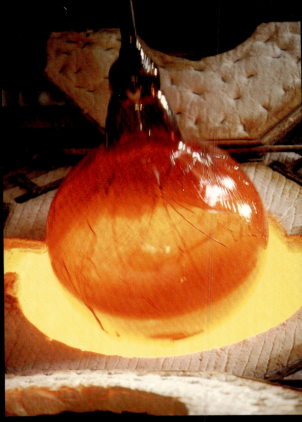
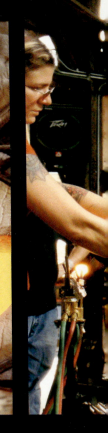

All names given left to right

TOP ROW

Left: Jon Ormbrek, Kelly O'Dell, George Stroemple, William Morris, Randy Walker.

Second from right: Kelly O'Dell, Shelley Allen, William Morris, George Stroemple, Rahman Anderson.

Right: William Morris.

MIDDLE ROW

Left: Jon Ormbrek.

Second and third from left and second from right: William Morris.

Right: Ross Richmond.

BOTTOM ROW

Left: George Stroemple, Rahman Anderson, Raven Skyriver, Kelly O'Dell, William Morris.

Second from left: Karen Willenbrink.

Second from right: William Morris.

Right: William Morris, Kelly O'Dell.

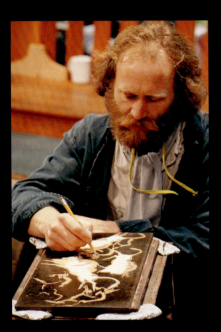
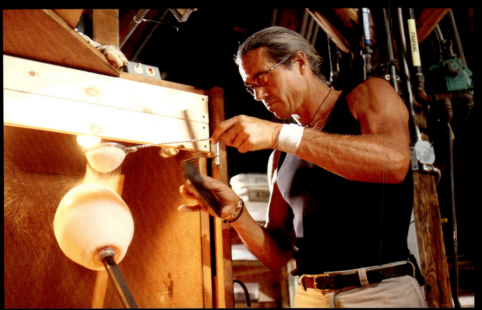

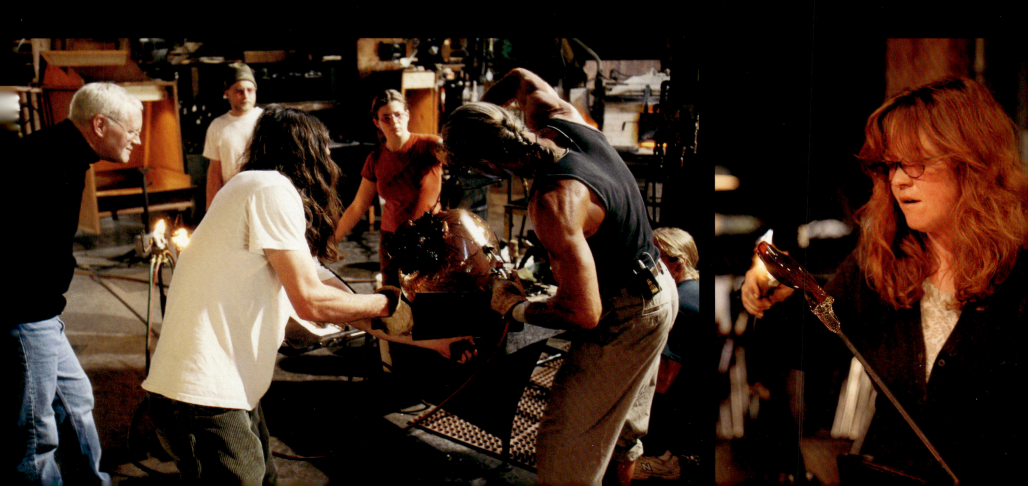

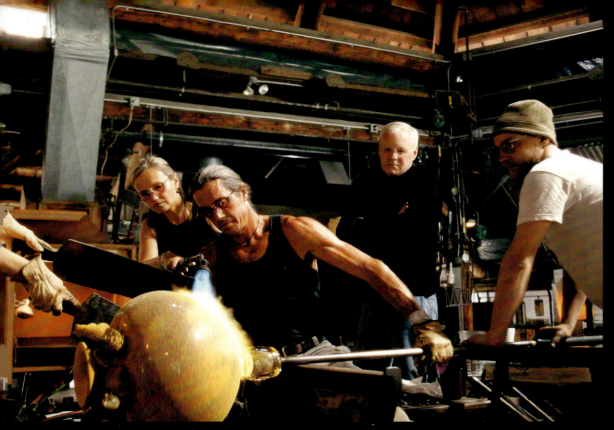
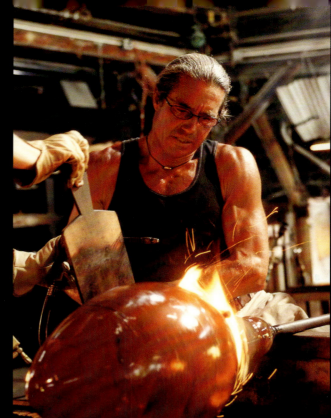

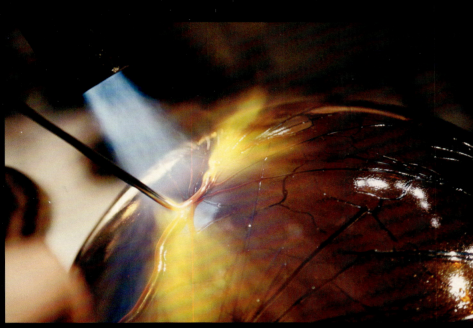
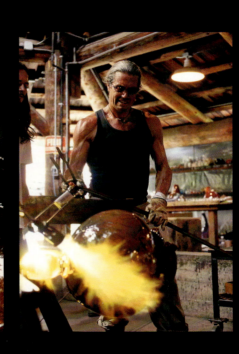
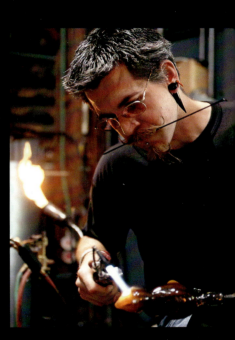
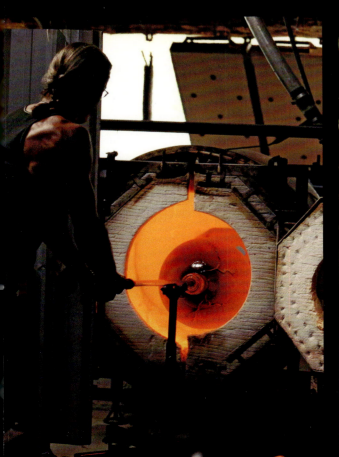
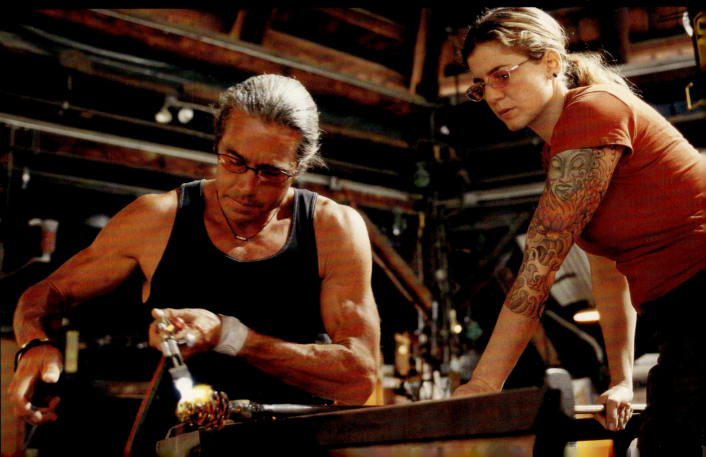

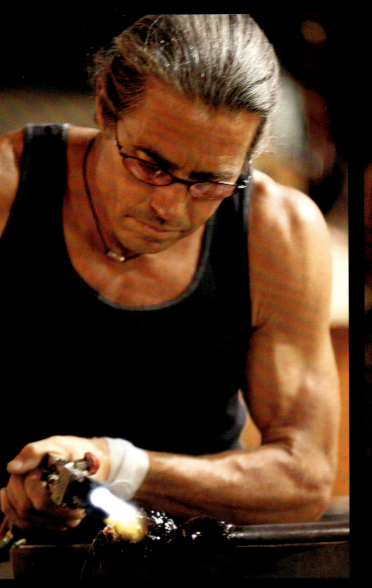
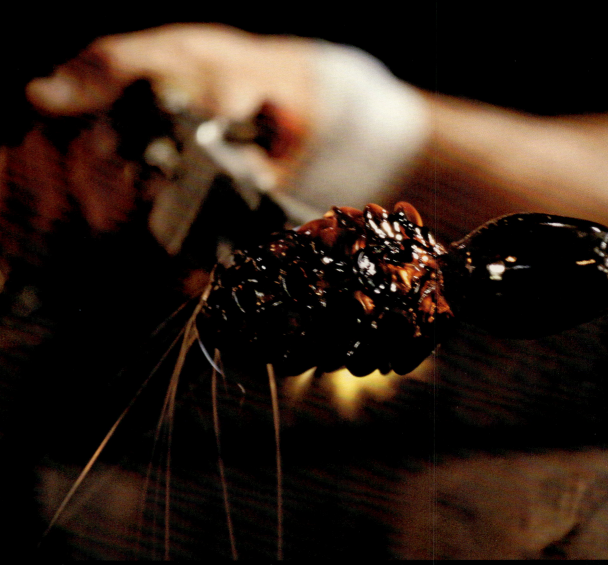

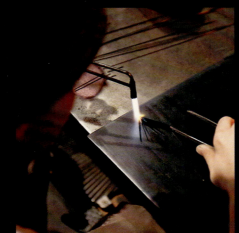
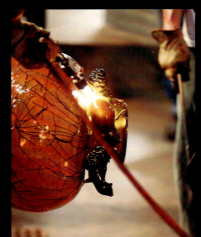
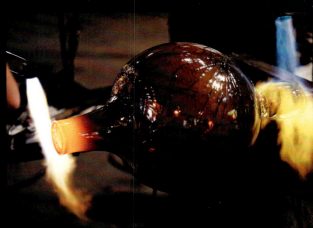

Top left: William Morris.

Bottom left: Kelly O'Dell, Ross Richmond, William Morris, Rahman Anderson, Randy Walker.

Bottom right: Rik Allen.

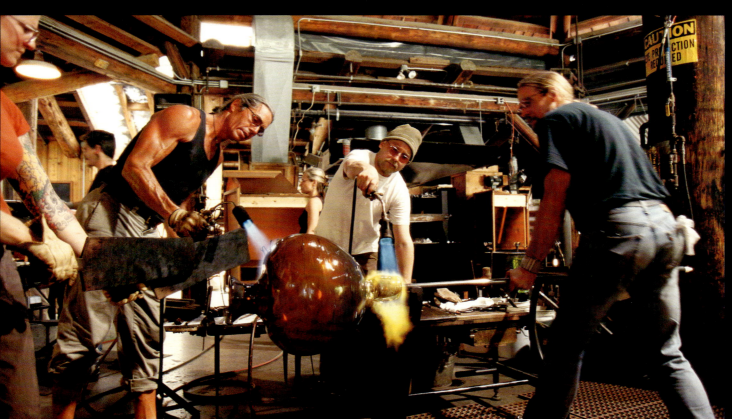

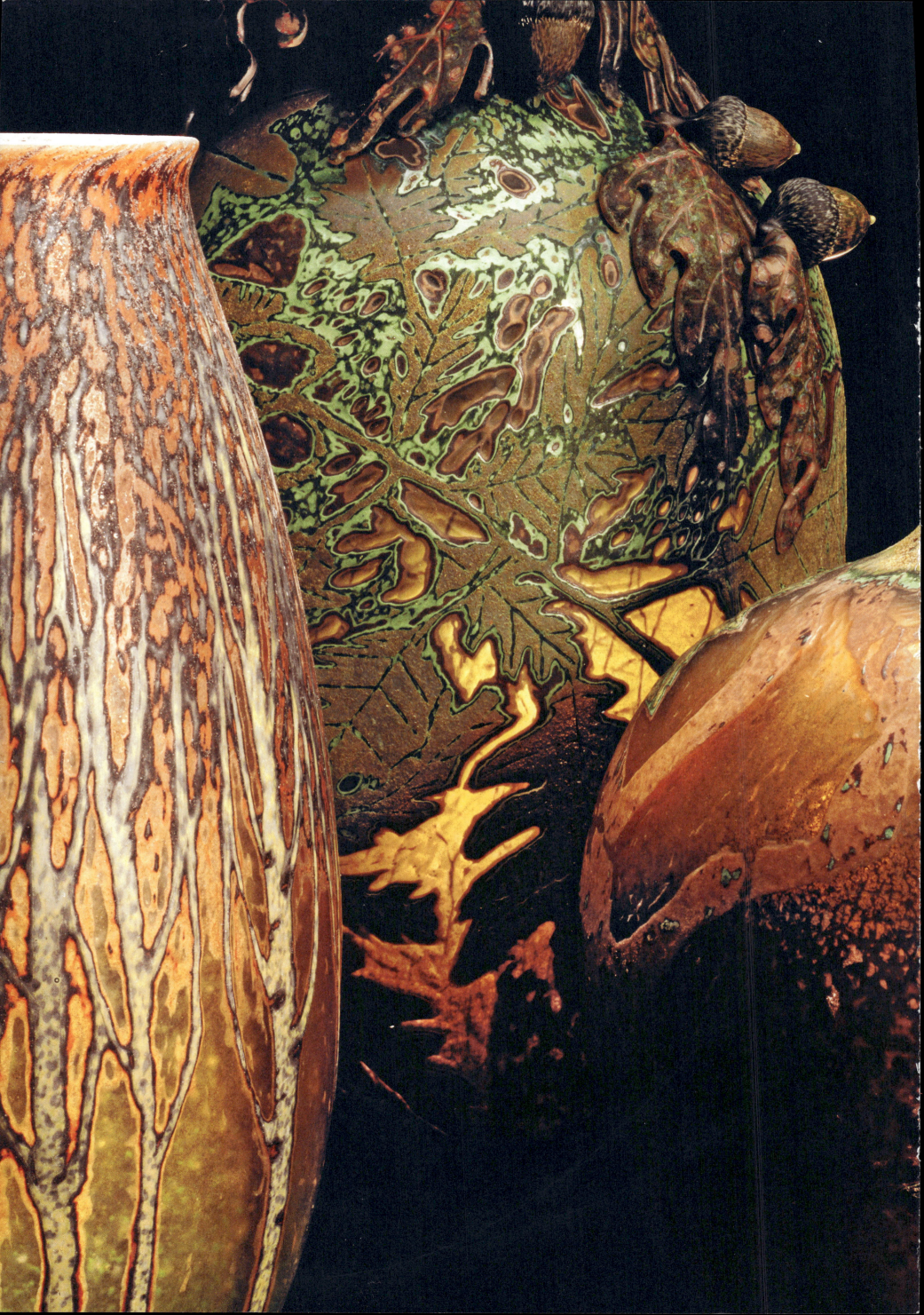